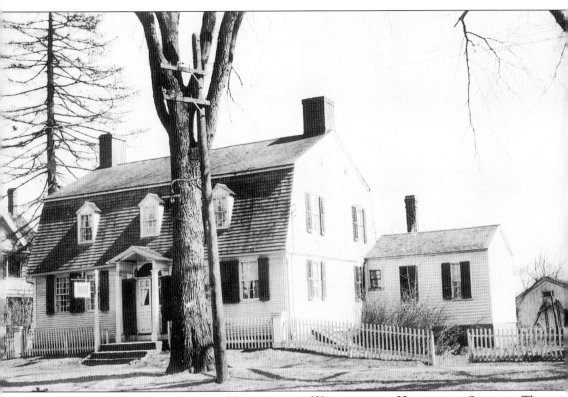

THE SAMUEL PARSONS HOUSE, HOME OF THE WALLINGFORD HISTORICAL SOCIETY. The Parsons House, located at 180 South Main Street, in the late 1700s served as a stage stop on the road between New York and Boston. It was later home to Capt. Caleb Thompson, who manufactured wagons, carriages, and coffins. It was donated to the society in 1920 by his granddaughter, Fannie Ives Schember.

IMAGES
of America

WALLINGFORD

The Wallingford Historical Society

ARCADIA
PUBLISHING

Copyright © 1999 by The Wallingford Historical Society
ISBN 978-0-7385-0075-1

Published by Arcadia Publishing
Charleston SC, Chicago IL, Portsmouth NH, San Francisco CA

Printed in the United States of America

Library of Congress Catalog Card Number: 9962498

For all general information contact Arcadia Publishing at:
Telephone 843-853-2070
Fax 843-853-0044
E-mail sales@arcadiapublishing.com
For customer service and orders:
Toll-Free 1-888-313-2665

Visit us on the Internet at www.arcadiapublishing.com

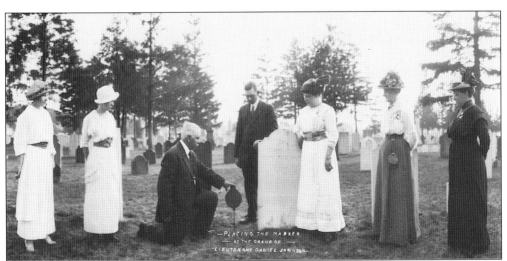

THE PLACING OF THE DAUGHTERS OF THE AMERICAN REVOLUTION MARKER ON THE GRAVE OF LT. DANIEL JOHNSON, C. 1910. The ladies of the Daughters of the American Revolution placed a marker on the grave of Daniel Johnson in the Center Street Cemetery.

CONTENTS

Introduction		7
Acknowledgments		8
1.	Street Scenes	9
2.	Commercial Buildings	17
3.	Schools and Sports	31
4.	Factories and Mills	43
5.	Transportation	53
6.	Beneficent Wallingford	61
7.	Special Occasions and Entertainment	69
8.	Wallingford under Siege by Mother Nature	83
9.	Around the Town	91
10.	Public Services	105
11.	Farms and Orchards	117
12.	Yalesville	123

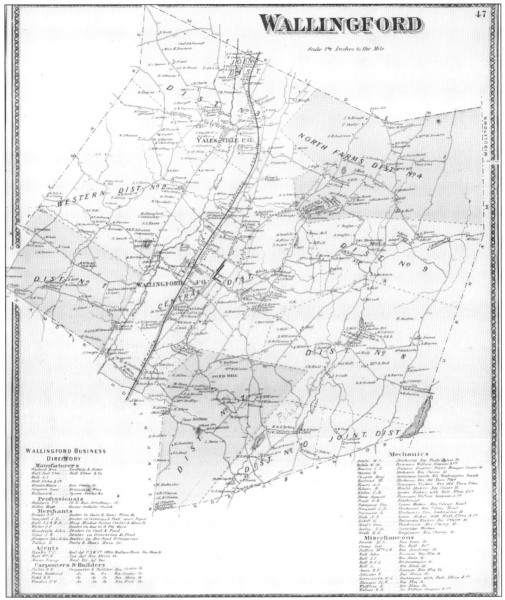

WALLINGFORD AS IT APPEARED IN THE 1868 MAP PUBLISHED BY BEERS. Wallingford, founded in 1670, was much different from the town shown on the above map. At its founding, it included what would later become Cheshire in 1780 and Meriden in 1806, as well as part of Prospect. As centers of population grew, first the western parish, and later the northern parish, petitioned to become their own towns. Wallingford, although much smaller after separation, is still one of the larger towns in Connecticut, since it still contains some 41.7 square miles. In the map above, the town is shown as being divided into ten school districts, one of which was shared with students from present-day Northford. This was before consolidation of the Central District and the creation of Wallingford High School. Some familiar names of the district schools are Pond Hill, Parker Farms, Cook Hill, and Yalesville. Others, such as Tylers Mill, Muddy River, North Farms, Northeast Farms, South Main, and District Five, have faded into history.

Introduction

Founded in 1670, Wallingford was the first interior settlement of the New Haven Colony. The site, flanking the Quinnipiac River, was selected by men such as John Moss Sr., John Brockett Sr., Nathaniel Merriman, and Abraham Doolittle. In the court in Hartford on May 9, 1671, the location of the town was approved, and the name Wallingford was first applied to this village. John Moss, a native of the Wallingford in Berkshire, England, is traditionally credited with naming our town.

The area, with its many streams flowing into the Quinnipiac, provided easy access to water power, initially for gristmills and sawmills, and later for our flourishing Britanniaware and silver industries. The latter, along with the factories in Meriden, made these two Connecticut towns the center of the silver industry in America for many years in the 19th and 20th centuries. This industry has now all but disappeared, and has been replaced with many smaller factories as well as burgeoning high technology and pharmaceutical industries. But through all the changes over nearly 330 years, Wallingford has retained its New England small-town image thanks to the efforts of many people and organizations, particularly during the 20th century.

In trying to define the essence of Wallingford, we are fortunate to have the aid of photographs from the early 1860s to 1960. They allow us to view many aspects of the town that have changed over the years. The ones included in this volume are but a sample of the rich history of the town. Making the selections required the committee to put in many hours during the past six months, first in reviewing the pictures the Wallingford Historical Society has, and then sourcing additional photographs from our friends and neighbors. The members of the committee were Robert N. Beaumont (Co-Chairman), Patricia A. Chappell, Raymond Chappell (Co-Chairman), Debra Foley, Helena O'Connell, Barbara Peters, David Peters, Joann Pirro, Marie Russell, Nell Short, and Jean Whitehouse.

ACKNOWLEDGMENTS

Much appreciation is extended to the following:

Photograph Committee members:

Robert N. Beaumont, Co-Chairman
Patricia A. Chappell
Raymond Chappell, Co-Chairman
Debra Foley
Helena O'Connell
Barbara Peters
David Peters
Joann Pirro
Marie Russell
Nell Short
Jean Whitehouse

Private collectors and others:

R. Bailey, H. Barnes, L. Barnes, N. Beaumont, G. Boyd, C. Burghoff, B. and K. Foster, E. Gilbert, D. Hall, N. Hall, R. Harrington, D. and K. Henry, B. Hocking, J. Holloway, P. Johnson, P. Kalinauskas, A. and B. Killen, W. LeFebvre, R. McMahon, H. Pattee, N. Rose-Redling, J. Rogers, R. Smith, L. Sylvester, A. Trowbridge, R. Vansky, and M. Wooding

One
STREET SCENES

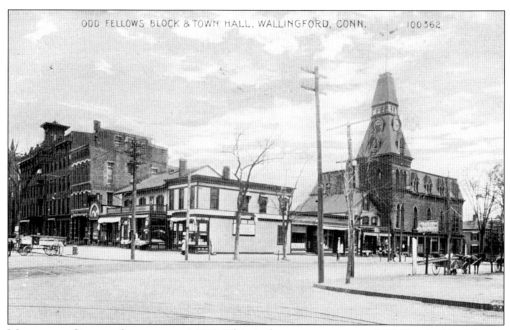

MAIN AND CENTER STREETS, C. 1905. This is the uptown center of Wallingford looking to the northeast. The tall building to the right of center is the town hall, built in 1868. The store on the corner was the photographic studio of J.W. Alderidge. The first brick building to the left of center is the Stanley Botsford Block, while the massive building further north is the William Wallace Block, later known as the Caplan building.

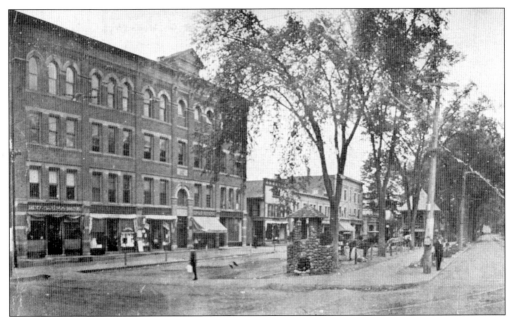

SIMPSON COURT, C. 1916. The large building on the left is Simpson Block, built in 1887. The third and fourth floors housed the Opera House run by George Wilkinson. The tenant on the near end of the building was the Dime Savings Bank. In the center is the old fieldstone drinking fountain. The uptown bandstand is toward the rear.

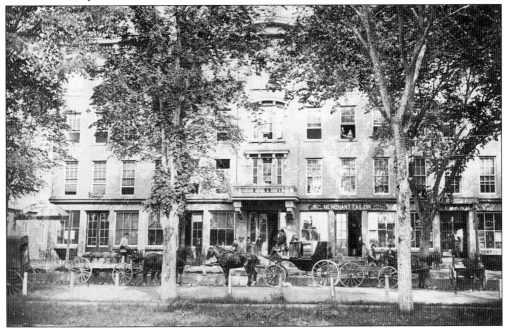

THE WILLIAM WALLACE BLOCK (LEFT) AND THE BOTSFORD BLOCK (RIGHT), C. 1885. At this time the block housed the law offices of J.C. Hinman, a merchant tailor, probably E. Whitworth, the Dime Savings Bank, and a pharmacy, possibly that of Thomas Pickford, who at one time shared space with the Dime. The Ladies Library and Reading Room, with their 1,400 books, occupied part of one of the upper floors.

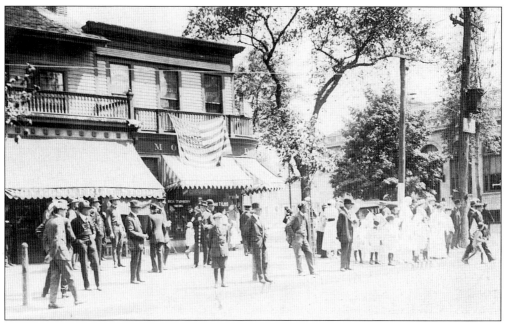

MAIN AND CENTER STREETS, C. 1917. This is a parade day, probably July 4. The Rovegno Fruit Store is at the left. The building with the American flag on it is home to James Moran's Drug Store, which would remain on that site for the next 70 years. In the background, is the U.S. Post Office, built in 1913.

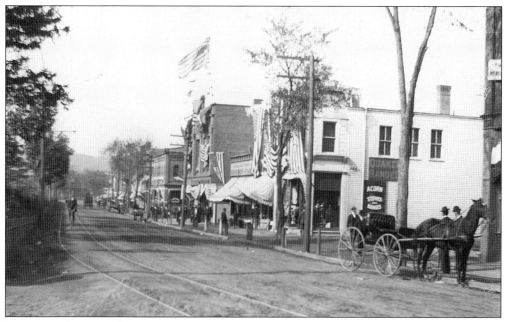

LOOKING WEST ON CENTER STREET FROM ORCHARD STREET, C. 1910. The cemetery was separated from the street by a fence, not the wall we know today. The trolley tracks, which ran very close to the cemetery fence, went from the railroad station to Constitution Street, carrying the commuters who worked at the Simpson, Hall & Miller Co., later known as Factory "L." The building on the far right became the W.T. Grant store later on.

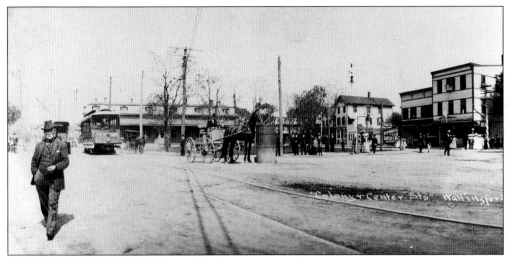

LOOKING TOWARD THE RAILROAD STATION FROM LOWER CENTER STREET. At the junction of Colony and Center Streets, a horse could refresh itself with a drink from a high-barrel trough. The "Dinky" took passengers from the railroad station to uptown and as far east as Simpson's Pond, before going to the trolley barn across from the Grange Hall on Center Street

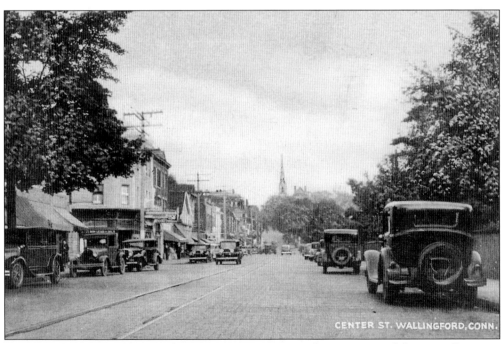

LOOKING EAST ON CENTER STREET FROM BETWEEN COLONY AND MEADOW STREETS, c. 1933. The age of the automobile has certainly arrived. You will note that the street is almost double the width from the picture on p. 11, and the cemetery wall now protects our ancestors from the hustle and bustle of the modern world.

A VIEW OF WALLINGFORD FROM THE MASONIC HOME AND HOSPITAL. This gives an almost aerial view of Wallingford from high on the hill at the Masonic Home overlooking Community Lake. To the right is the double-bow bridge on Hall Avenue, and the Watrous Manufacturing Company, later part of the International Silver Co. There is a lot of Wallingford to be found in this scene.

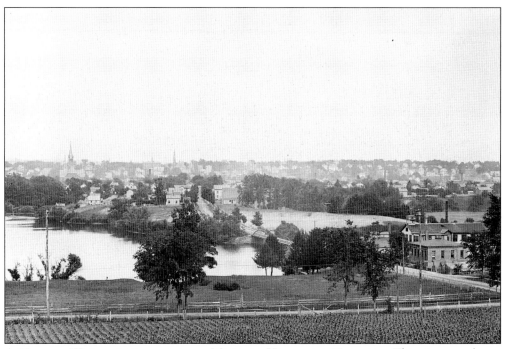

CENTER STREET, LOOKING EAST FROM THE TOWER OF THE TOWN HALL, C. 1870. Note the glass shop in line with the Simpson, Hall, Miller & Co. The shop burned in the late 1870s. This was the site of the first practical demonstration by John M. Hall of the automatic fire extinguisher (sprinklers) to a group of engineers who came from far and wide to witness it about 1875.

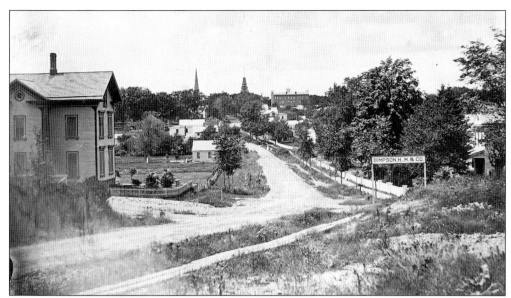

AN EARLY PHOTOGRAPH OF EAST CENTER STREET. This was taken from the present-day corner of Simpson Avenue, about 1885–86, before Simpson Block was built in 1887. The house on the left is still on the corner. The spire of the First Congregational Church, the bell tower of the 1869 town hall, and the outline of the Wallace Block are visible. As noted by the sign, the area to the right was home to Simpson, Hall & Miller, later Factory L of International Silver.

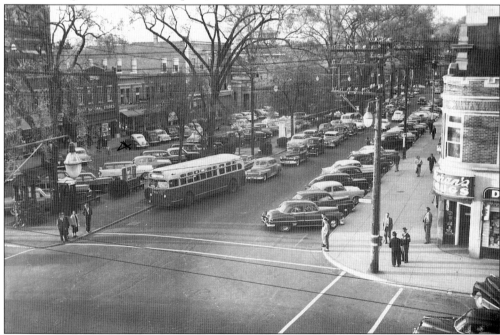

MAIN AND CENTER STREETS LOOKING NORTH INTO SIMPSON COURT FROM THE ROOF OF THE POST OFFICE, 1951. By this time, the trolley tracks had been tarred over and the bandstand moved to Doolittle Park. The fieldstone fountain is still standing, as is the white, wooden World War II memorial that listed all the people from Wallingford who served our country.

SLEDDING DOWN WALLACE STREET, LATE 1920S. Several of the Lobb family women are riding a long sled just west of where the YMCA is today.

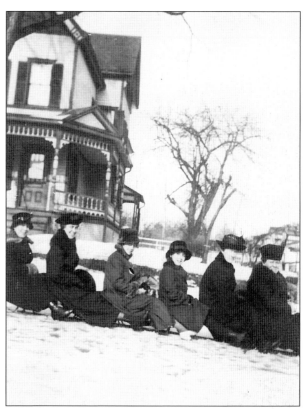

A HOUSE AUCTION, C. 1958. Auctioneer Red O'Connell, a well-known and beloved antique dealer and estate liquidator, tries to obtain the best prices in settling the estate of Herb Peterson on Union Street.

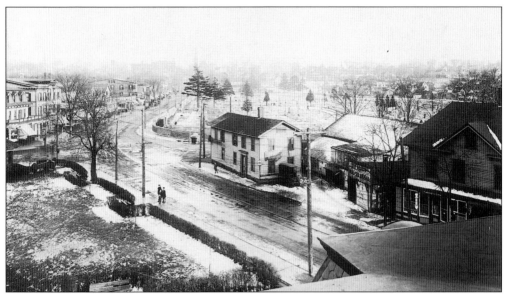

THE VIEW FROM THE ROOF OF THE RAILROAD STATION LOOKING EAST ON CENTER STREET, c. 1915. Reilly's Livery and Feed Store is on the lower right. On the extreme left is the fieldstone bandstand on the green. Center Street has been widened, and the wall has been installed at the cemetery.

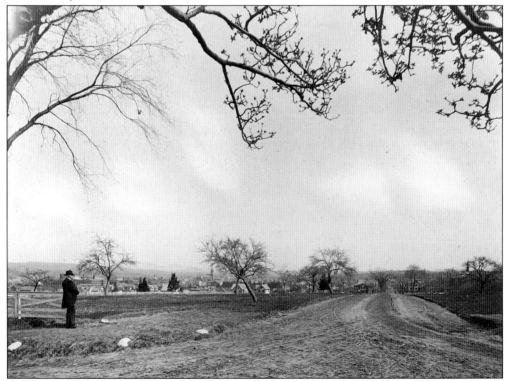

SOUTH WHITTLESEY AVENUE, C. 1895. Henry B. Hall looks from the south end of Whittlesey Avenue toward Ward Street just prior to his opening this area for real estate development. In addition to being a land developer, Mr. Hall served as borough warden for a number of years.

Two
Commercial Buildings

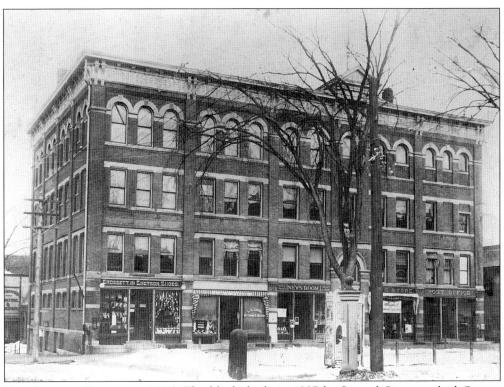

The Simpson Block, c. 1905. The block, built in 1887 by Samuel Simpson, had George Wilkinson's Opera House on the top two floors; the second floor had offices such as that of well-known attorney C. Albert Harrison. The stores at that time were the Crossett & Emerson Shoe Store, L.R. Cook's dry goods and notions, the New Haven News Room, Pixley's Drug Store, and the post office. This was before the original fieldstone fountain was constructed at the south end of Simpson Court.

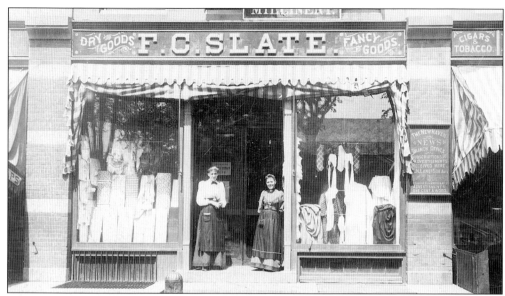

F.C. Slate's Millinery Store, c. 1889. This dry goods store occupied the second shop in Simpson Court, prior to Lorenzo Cook's store (noted on the preceding page). It was later the location of Cahill's, a well-known women's store in the mid-1900s.

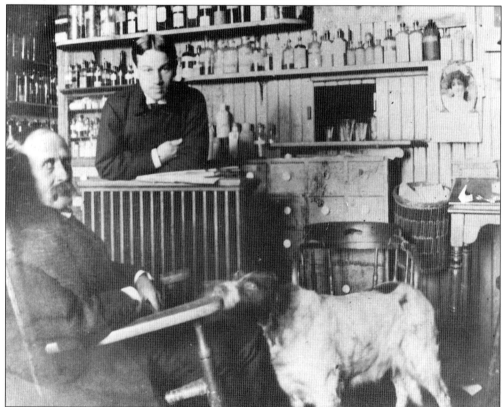

The Back Room in Pixley's Drug Store. Mr. Pixley is on the left along with Fred Marx, who bought the business upon Mr. Pixley's retirement. This later became Stimpson's Pharmacy.

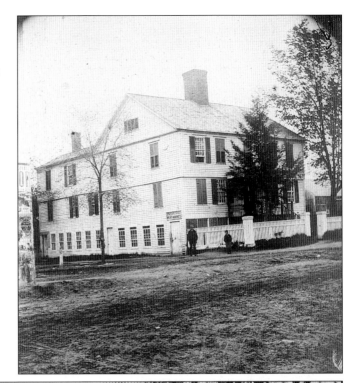

LOOKING SOUTHEAST TOWARD THE SITE OF THE CURRENT POST OFFICE, c. 1863. The building we see houses the Main Street Meat Market. This was once a tavern with a large taproom, and was reputedly moved to this location from down near Orchard Street. The pole at the left is the Liberty Pole that Moses Yale Beach had erected at the start of the Civil War in 1861.

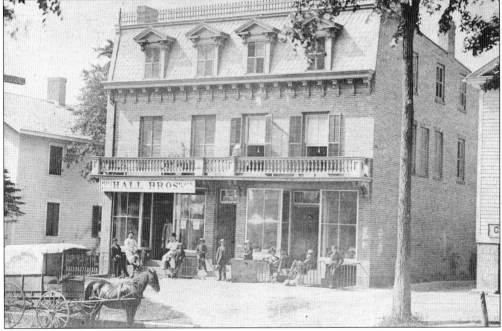

THE JONES BLOCK, C. 1895. This was located on the south side of Center Street, west of today's Gallagher Travel. The picture shows the Hall Brothers' Meat Store and delivery wagon. The store was operated by Henry D. and Julius Hall. The right side was later occupied by Heilman's Bakery. The building was demolished to allow for the construction of the current post office.

THE F.H. SMITH GROCERY STORE, 1898. It was a thriving grocery and dry goods store located at the northeast corner of Academy and North Main Streets. Shortly after this picture was taken, Harry D. and William F. Pattee bought the business and moved it to the Dickerman Block in Simpson Court. This house was later used as a medical office by Dr. Alfred St. James.

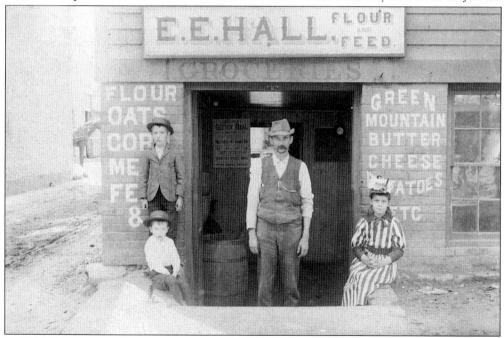

THE E.E. HALL FEED STORE, C. 1893. This was just west of the Jones Block, noted on p. 19, at 353 Center Street. In the picture are Almon E. Hall, Edwin E. Hall (owner), Minnie Hall (E.E.'s son and daughter), and an unidentified little boy in front. This building was later home to Charles Gammon's gas station, and later still to Andy Ohr's Texaco station.

THE WALLINGFORD TOWN HALL WITH STORES ON THE FIRST FLOOR, PRE-1910. The town derived income from the storefronts before it needed the space for offices. This was well before the police occupied the east end of the building.

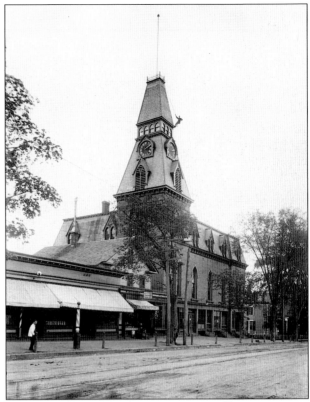

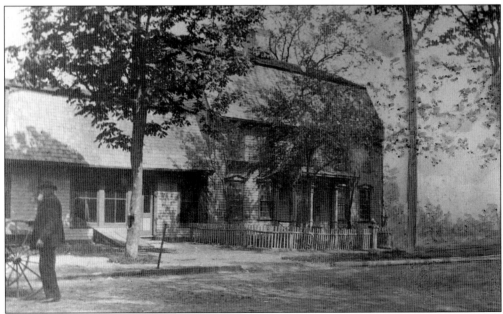

THE CARRINGTON STORE ON SIMPSON COURT. Started about 1810, this was Wallingford's first department store. It was said to have anything you could think of. During the Revolution, the Royal Governor of New Jersey, William Franklin, son of Benjamin Franklin, spent several months under house arrest here.

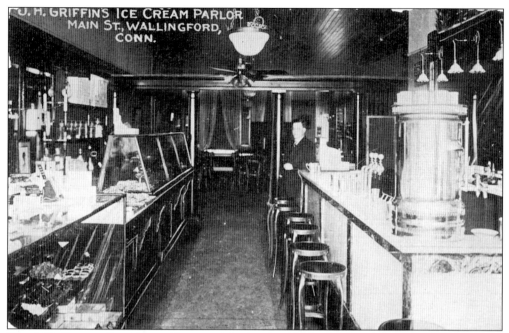

THE J.H. GRIFFIN ICE CREAM PARLOR. This was at 17 North Main Street in Simpson Court. Mr. Griffin had a "Large Cool" ice cream parlor and provided Victrola music for diners.

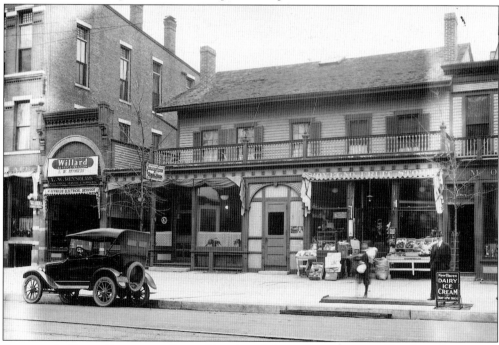

ROVEGNO'S FRUIT STORE AND LOUIS REYNOLDS' AUTO BATTERY AND ELECTRIC SHOP, JUST NORTH OF CENTER AND NORTH MAIN, C. 1921. Mr. Reynolds ran a large industrial electric company from this location as well as selling Willard automobile batteries. Just to the right of his store was a delicatessen and dining room, and then the fruit store. Anyone care for a "brick" of New Haven Dairy ice cream before going for a drive in the Model "T" touring car at the curb?

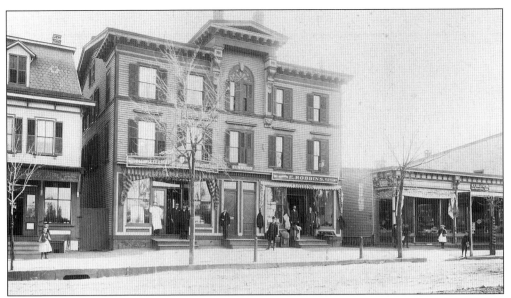

THE HOTEL ELMWOOD, C. 1896, AT 12 CENTER STREET. The saloon with its Narrigansett Lager sign on the left was run by Edward Dailey, while the E. Robbins' Clothing Store was to the right selling "gents furnishings." The first building to the right housed Dondero's Confectionery, and the next was M.N. Brainerd's Cash Provision House.

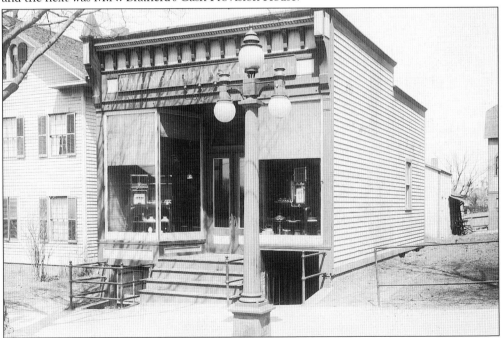

THE WALLINGFORD GASLIGHT COMPANY AT 210 CENTER STREET, 1914. The WGC was incorporated in 1883 with a capital of $42,000. The officers were W.J. Leavenworth (president), E.M. Judd (treasurer), and, B.A. Treat (secretary). In 1905 the company was sold to C.C. Thompson & Sons of New Haven and sold again in 1927 to the Utilities Power and Light Corp. of Chicago. The WGC provided street lighting for over 30 years until electrical lighting became more feasible.

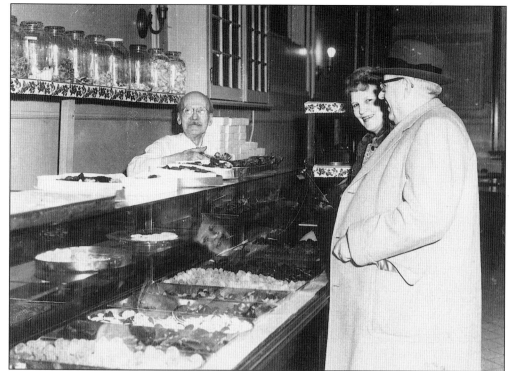

THE O.D. FOOTE ICE CREAM AND CANDY STORE, 198 CENTER STREET, C. 1960. Oliver Foote is pictured with patrons Maybelle and Anthony Kowalski. This store was a fixture on Center Street for many years. O.D. had some of the best ice cream around, made for a number of years by Leo DelRosso. O.D.'s fruit salad and "dusty" sundaes were among his more popular treats.

A PRANK FOR HALLOWEEN, C. 1885. Some of our young men of yesteryear moved this outhouse along with many signs to a place of prominence in front of the water commisioner's office. To the left, with the fancy gingerbread, is the old Gothic schoolhouse, which was moved further up North Main in the late 1890s, and to the right is the house of Moses Yale Beach.

AN EARLY BANKING SCENE AT THE FIRST NATIONAL BANK, 35 S. MAIN STREET. This bank, in the late 1950s, became part of Union & New Haven Trust Co., now First Union Bank. At the time of this photograph, however, it shared its quarters with the Dime Savings Bank. From left to right are Willis A. Trask, teller; William H. Newton, cashier; and Bert Hirous, clerk.

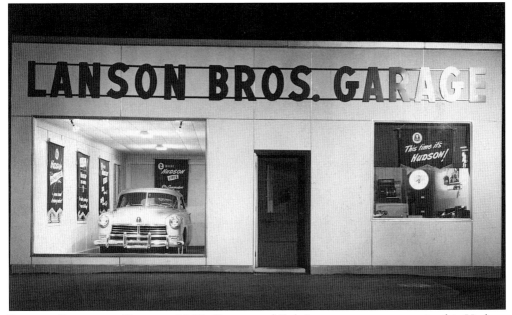

LANSON BROTHERS GARAGE, 1948. George and Bob Lanson were partners in this Hudson dealership at 180 North Colony Street. This was a typical old-style, one-bay showroom. In addition to Hudsons, the Lansons sold several long-forgotten brands of trucks—General, Stewart, and Federal.

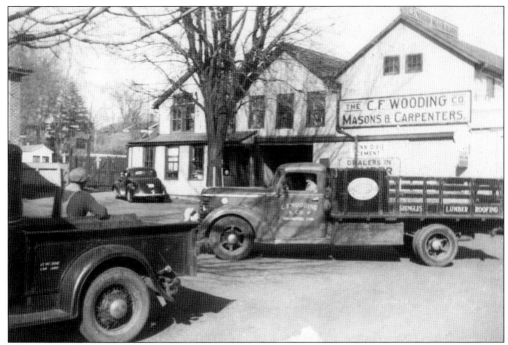

THE C.F. WOODING COMPANY, WALLACE AVENUE, IN THE EARLY 1940S. The Wooding Co., started in 1868 by Newton C. Wooding and most ably carried on by his son, Charles Fenn Wooding, was responsible for the construction of many commercial buildings and residences from the late 1800s onward. It also had a fine lumberyard and mill at this same location for over 100 years.

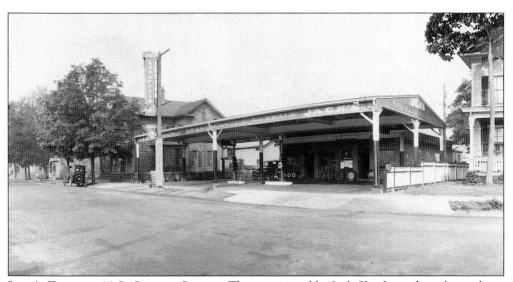

JACK'S TEXACO, 65 S. COLONY STREET. This was owned by Jack Sheehy and was located just south of the current Portuguese-American Club. Have you ever heard of Norwalk Tires?

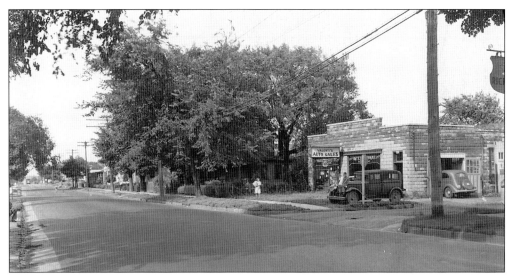

AN EARLY PHOTOGRAPH OF VALENTI'S AUTO SALES ON NORTH COLONY STREET. This photograph was taken when they sold Nash and Lafayette automobiles. The business started with a gas station and a one-bay showroom—somewhat different from the Valenti's Chevrolet of the 1990s.

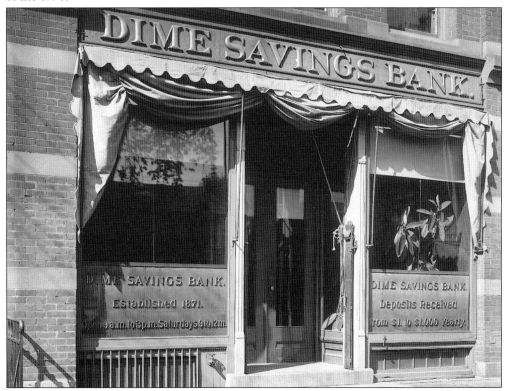

THE DIME SAVINGS BANK AT 2 NORTH MAIN STREET, 1917. This is when Dime was the size of a single storefront with assets of about $2 million. They even had Saturday banking back then. Based on the sign on the right, it looks like a customer could only make deposits of a maximum of $1,000 per year.

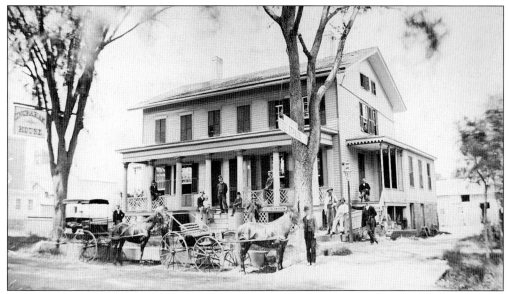

THE INGRAHAM HOUSE ON CENTER STREET ABOUT 1875. This hotel, later known as the Wallingford Hotel, was located at 398 Center Street The sign on the right side of the main porch says "Ice Cream Room." It looks like that was in the basement, perhaps because it was easier to keep ice cream cold down there.

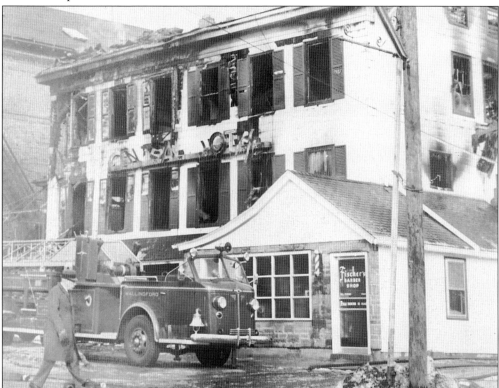

THE HOTEL CENTRAL FIRE, JANUARY 8, 1963. This was a successor name to the Wallingford Hotel. It was ravaged by a fire that caused the deaths of several people.

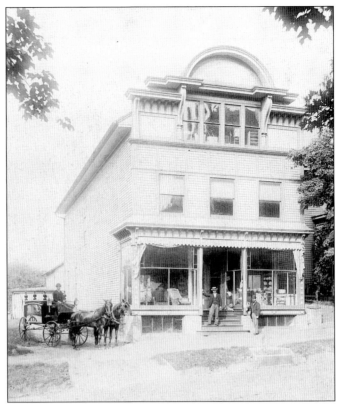

GRISWOLD'S FURNITURE STORE AND UNDERTAKING PARLOR, C. 1885. Daniel Griswold came to town in 1870 and plied this dual trade for over 40 years. His building was located on Center Street, just to the east of the Holy Trinity School.

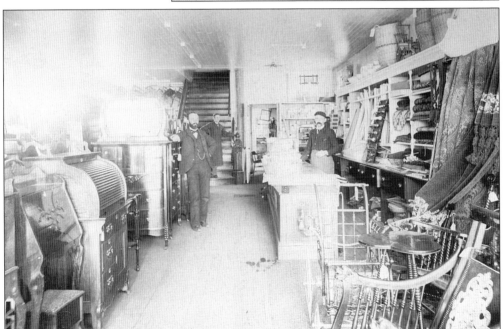

THE INTERIOR OF GRISWOLD'S FURNITURE STORE, C. 1885. Daniel Griswold, with his neatly trimmed beard, is standing to the left. The funeral parlor was on the second floor. Mr. Griswold stayed at this location until he sold the business in 1912 to Carl W. Bailey.

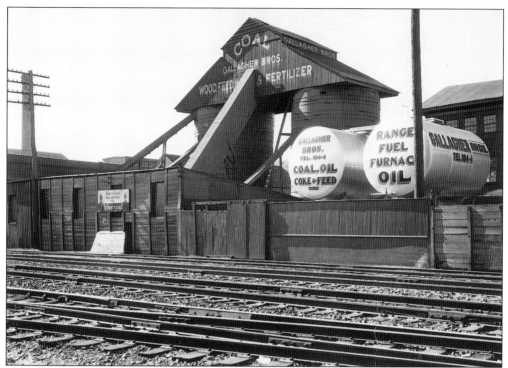

GALLAGHER BROS., DEALERS IN COAL, RANGE AND FURNACE OIL, WOOD, FEED, AND FERTILIZER, C. 1940. Located on the south side of Quinnipiac Street, on the west side of the tracks, Gallagher Bros. was a provider of various fuels for over 50 years. Although long disused, the coal silos are still standing.

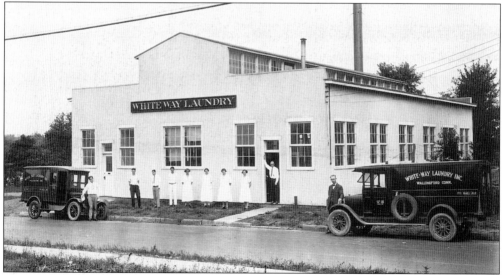

THE WHITE WAY LAUNDRY, 1925. This laundry, on the banks of Community Lake, was built in 1924 by Louckes and Clark for Messrs. Bates and Watrous of Deep River. This was their second branch after the main facility in their hometown. In 1932, George Grasser started working there as a driver, and in 1936 he became manager of the laundry, which he bought in 1944.

Three
SCHOOLS AND SPORTS

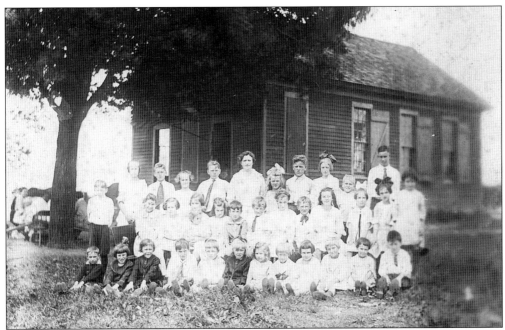

PARKER FARMS SCHOOL, JUNE 1922. The teacher, in the middle of the rear row, was Mrs. Alice Holmes Bullock. Please note that the girls are all wearing dresses and most of the boys are wearing ties. This was probably a special occasion, perhaps the last day of school that year.

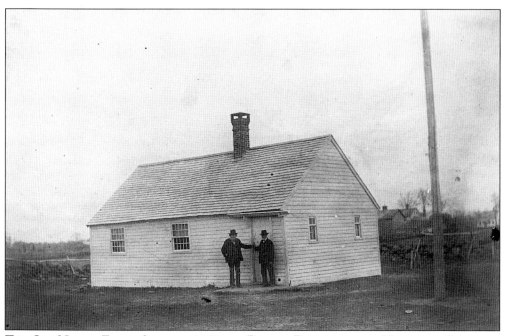

The Old North Farms School, 1893, on Barnes Road opposite Northrup Road.

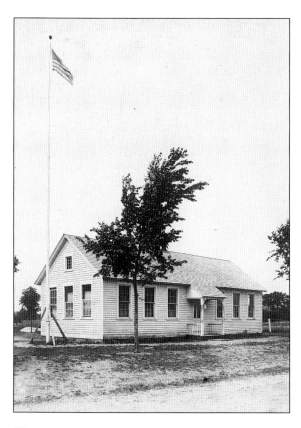

The North Farms School as a Two-Room Schoolhouse. This new school was built in 1903 on the same site as the old school.

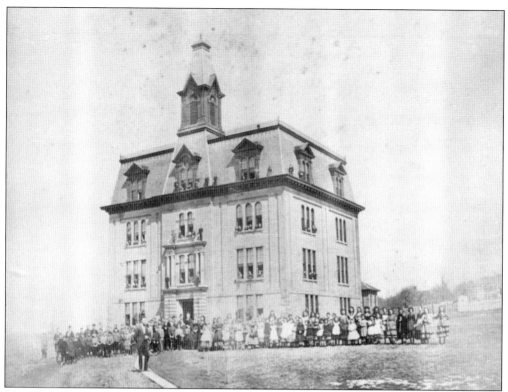

THE NORTH MAIN STREET SCHOOL, C. 1875. The student body and principal are pictured in front of and on the fourth-floor ledge of the original North Main Street/Central District School. The top two-and-a-half floors were destroyed by the August 1878 tornado (see the chapter "Wallingford Under Siege" for tornado damage). Mr. Beach on his deathbed in 1868 gave the town 3 acres on which to build the school.

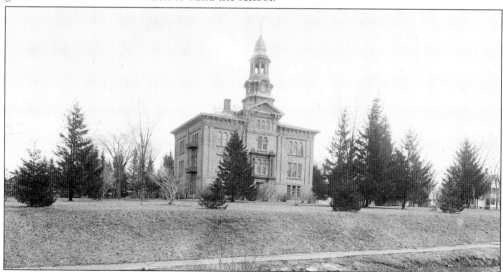

THE NORTH MAIN STREET SCHOOL/WALLINGFORD HIGH SCHOOL, LATE 1880s. This school faced south toward Christian Street on the current site of the Moses Y. Beach School, and served Wallingford students for over 70 years, from 1879 to 1950.

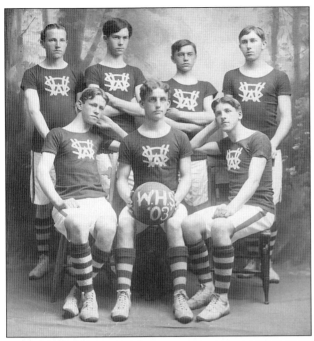

THE WALLINGFORD HIGH SCHOOL BASKETBALL TEAM, 1903. Shown here are, from left to right, as follows: (front row) unidentified, John J. Brosnan, and Almon E. Hall; (back row) Joseph Fleming, Frank Bridget, Bryant Burke, and Morton Allderidge.

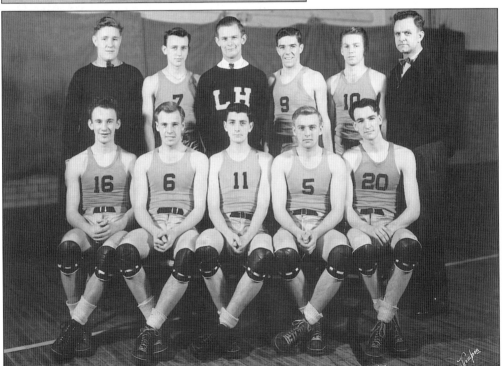

THE 1940 CLASS "B" STATE CHAMPIONS. This Lyman Hall High School basketball team brought home the first state championship to Wallingford. They are. from left to right, as follows: (front row) Charles Sabo, Stan Naszniec, Ken Spellacy, Frank Naszniec, and George Magee; (back row) manager Jim Lee, Walter Jakiela, Joe Balon, Bob Condon, Roger McMahon, and coach Langdon Fernald.

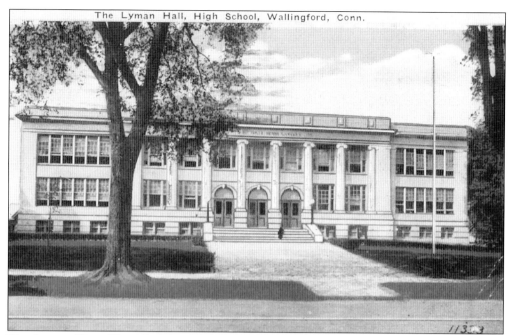

THE LYMAN HALL HIGH SCHOOL, 1922. Built in 1916, it served as our first free-standing high school for 40 years. It later became the Robert Early Junior High School and then the Robert Early Middle School, before being converted for use as our present town hall.

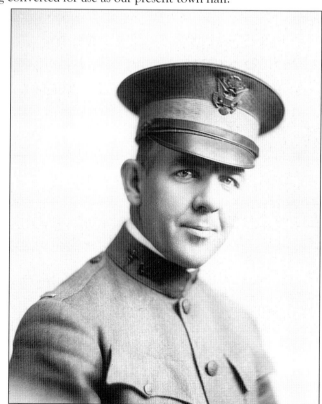

FIRST LT. MARK THOMAS SHEEHAN, 1917. Doctor Sheehan, as he was better known in Wallingford, served as a medical officer in the U.S. Army in World War I. He was honored for his many years of service to our community both as a family doctor and as the town's health officer by having our new high school named for him in 1971.

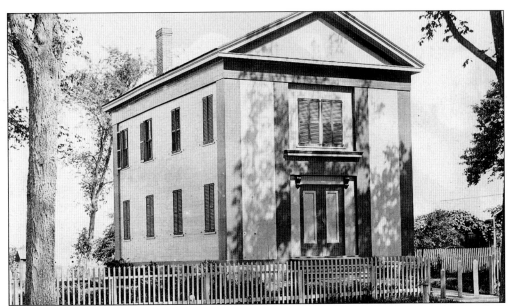

THE SOUTH MAIN STREET SCHOOLHOUSE, C. 1895. The Sixth District School, as it was called, was built in 1824, replacing the original school, which was built in 1724. One of the students of the original school was Lyman Hall, who later signed the Declaration of Independence and became governor of Georgia. This building, which stood across from the historical society, was used until about 1916, and was taken down in 1921.

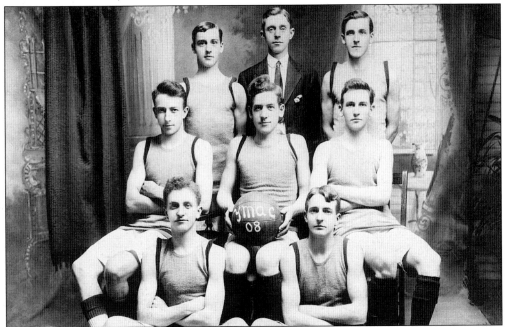

THE YMAC BASKETBALL TEAM IN 1908. No, it is not a transposition of YMCA. It really is the Young Men's Athletic Club of Wallingford. This club was founded in 1902, and continued in existence for over 50 years. Shown here are, from left to right, as follows: (front row) ? LaMontagne and Howard Lane; (middle row) Howard Cooke, Ed Olmstead, and unidentified; (back row) Alfred Taylor, William Smith, and Almon E. Hall.

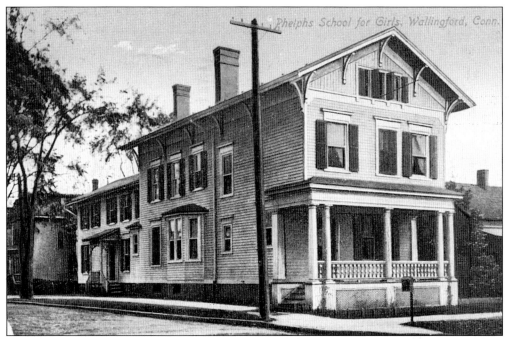

THE PHELPS SCHOOL FOR GIRLS. This building on the corner of Academy and North Main Streets was home to the Phelps School for Girls from 1900 to 1905. Miss Edith Lane Carrington owned the school and was one of the teachers. Margaret Tibbetts Taber, on whose property the Wallingford Public Library sits, was one of the students in this period.

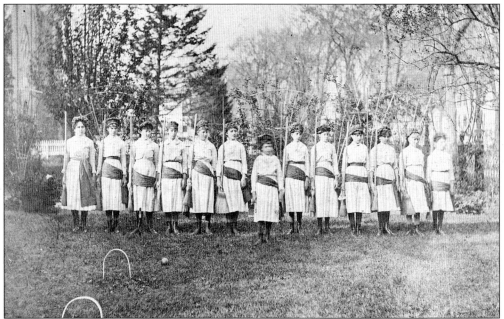

ANYONE FOR BROOM CROQUET? These young ladies, believed to be students at the Phelps School, lined up for this picture before playing a game of croquet with their brooms on the lawn of former home of Moses Y. Beach. To the right, the iron fence with its fancy arch is visible, while the First Baptist Church can be seen to the left in the rear.

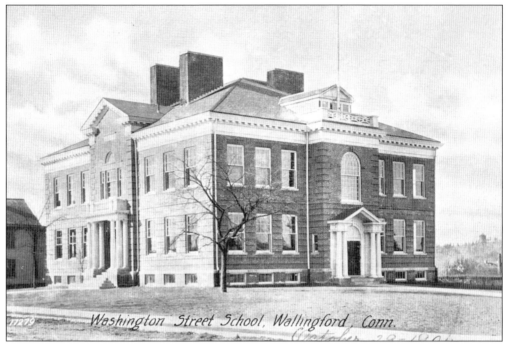

THE WASHINGTON STREET SCHOOL, C. 1909. This kindergarten to eighth grade school served the southwest part of town for close to 70 years. The Thomas J. McKenna elderly housing complex now occupies the property at Quinnipiac and Washington Streets.

THE COOK HILL SCHOOL WHEN IT WAS A ONE-ROOM SCHOOLHOUSE. This was the second Cook Hill School, and was located on the northeast corner of Cook Hill and School House Road. When it closed in 1935, it was the last one-room school in town.

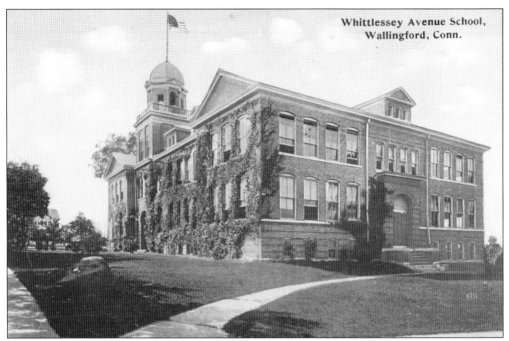

THE WHITTLESEY AVENUE SCHOOL. This school was built in 1897 and continued as a public school for over 80 years. It is now home to the Heritage Christian Academy.

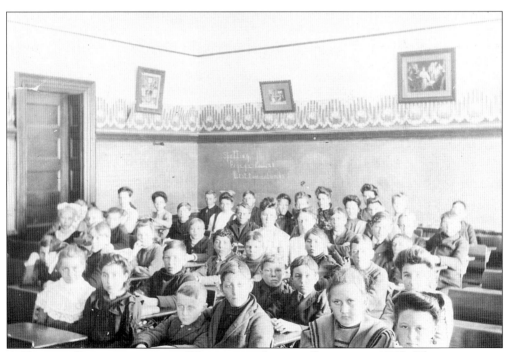

A TYPICAL CLASSROOM AT THE WHITTLESEY AVENUE SCHOOL, C. 1908. There were over 40 students in this class. Take note of the how close together they are sitting due to the manner in which the chairs/desks were made.

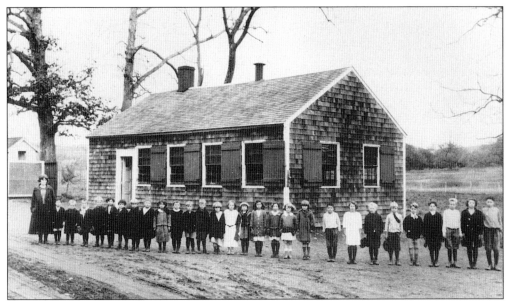

THE MUDDY RIVER SCHOOL, 1922. This school was at the foot of Whirlwind Hill, just west of the Muddy River on the north side of the road. In earlier days, this was the District Nine School. It was eventually closed so that the MacKenzie Reservoir could be built. Town selectmen gave the building to the Williams's boys in 1925 on the condition they would move it.

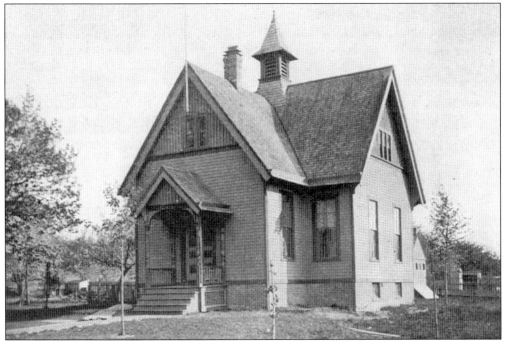

THE SIMPSON SCHOOL, C. 1894. This school was located south of Center Street, to the rear of the more recent school of the same name. In 1894, some 38 students of the first three grades attended classes here, and then continued their schooling at the North Main Street School for the higher grades.

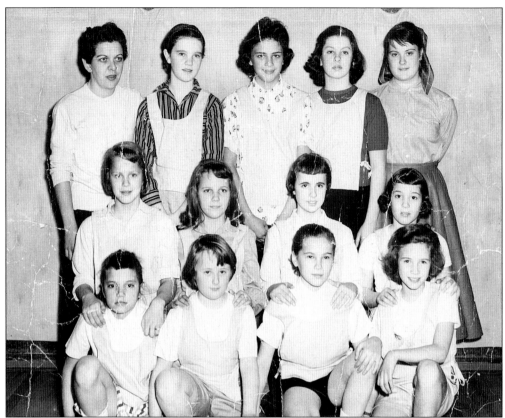

THE HOT CANARIES, 1955–56. The Debbie Basketball League, started by Robert J. Gannon, directed by Frank Rondo, and sponsored by the Wallingford Parks and Recreation Department in 1955 for fourth to eighth grade girls, was the first of its kind in Connecticut. Shown here are, from left to right, as follows: (front row) Barbara Totz, Judy Kittleman, Honora Bukowski, and Rosanne Gannon; (middle row) Barbara Sabo, Trudy Harkawick, Joan Corcoran, and Audrey Knope; (back row) Coach Helen Wall, Ellen Scott, Gail Porto, Sheila Arp, and Coach Barbara Kittelman.

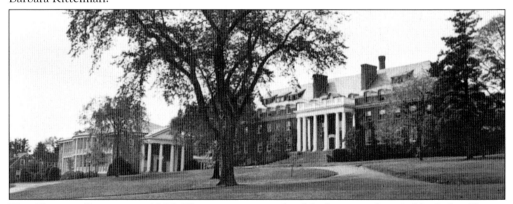

THE CHOATE SCHOOL, C. 1959. This preparatory school for boys was founded by Judge Choate in 1896. This is a view from Christian Street looking southwest toward the Hill House on the right and George and Clara St. John Hall. It is now Choate Rosemary Hall since Rosemary Hall returned to Wallingford from Greenwich in 1972.

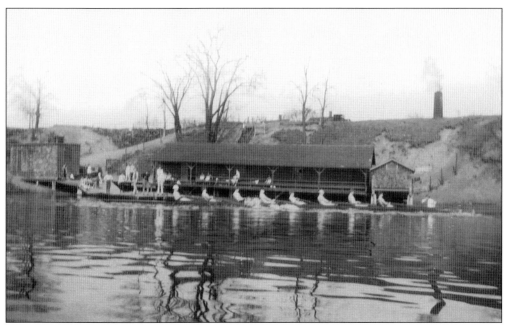

THE CHOATE CREW TEAM IN FRONT OF THE OLD BOATHOUSE ON COMMUNITY LAKE IN 1920. The Choate crew rowed on the lake for many years, until the dam broke in 1979. The smokestack in the background to the right is at the old rubber shop on Parker Street

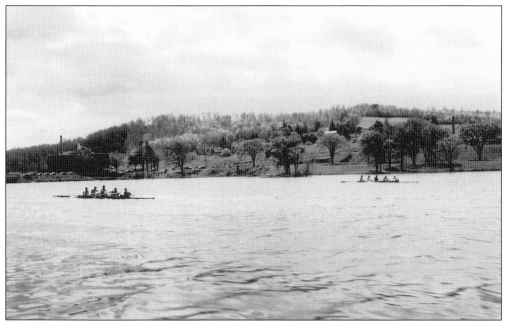

TWO FOUR-MAN SHELLS ON THE LAKE IN THE 1940S. Remember Community Lake with water in it? This is how it looked 50 years ago from the dock of the Choate boathouse looking to the southwest. The Masonic Home can just be seen over the trees above the shell to the right, while International Silver's Factory P. is visible above the shell on the left.

Four
FACTORIES AND MILLS

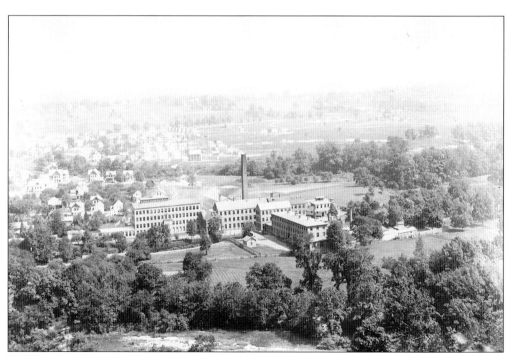

R. WALLACE COMPANY SILVERSMITHS, C. 1899. This company, which traced its roots to Robert Wallace in 1835, grew to be one of the largest silverware manufacturers in the country. Known for its excellent quality products, it provided hundreds of jobs for the people of Wallingford. It even produced its own electricity until the early 1930s with its own hydroelectric plant.

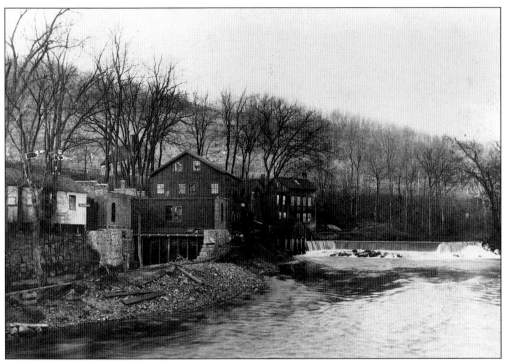

THE MUNSON MILL AND THE OLD "QUINNY" POWER PLANT, C. 1910. The mill and the power plant were just north of the Toelles Road bridge on the west side of the Quinnipiac River. The "Quinny" plant is the small brick building, which produced up to 3,500 watts of electricity in the early 1900s. The buildings all burned about 1930. The site is now under the Wilbur Cross Parkway.

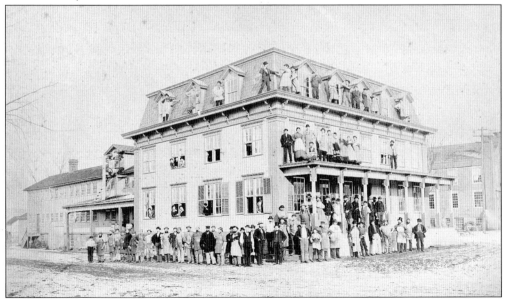

HALL, ELTON & COMPANY IN THE 1870s. Just to the north of the railroad station and to the west of the tracks, Hall Elton was founded in 1837. It produced silver-plated ware and German silver spoons until after the turn of the century.

THE WALLINGFORD WHEEL COMPANY, C. 1880. This firm, located north of the railroad station and west of the tracks, manufactured wagon wheels. The building, although over 150 years old, is still being used today. The predecessor company was started by John Milton Hall and operated by him and his father, Elihu.

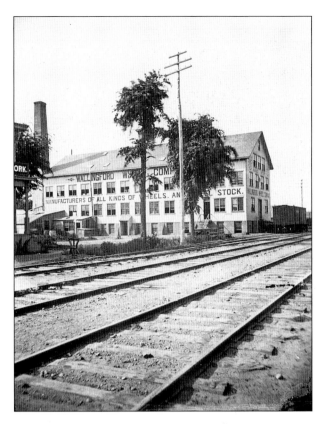

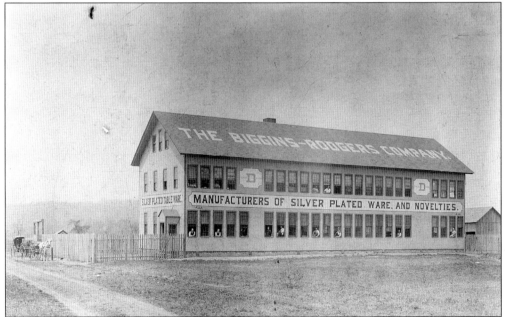

THE BIGGINS-RODGERS COMPANY, C. 1890. This manufacturer of silver-plated ware and novelties was located on Carlton Street. The office manager at this period was the father of Wallingford's first mayor, William D. Bertini.

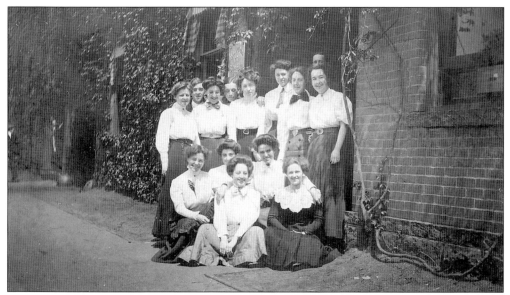

THE H.L. JUDD OFFICE STAFF, C. 1900. Hubert Judd's company made various types of hardware, including fancy metal picture frames, bookends, and other ornamental hardware. In the third row, standing second from the right, is Molly Gaherty. In the second row, kneeling on the right, is Mary Hanley.

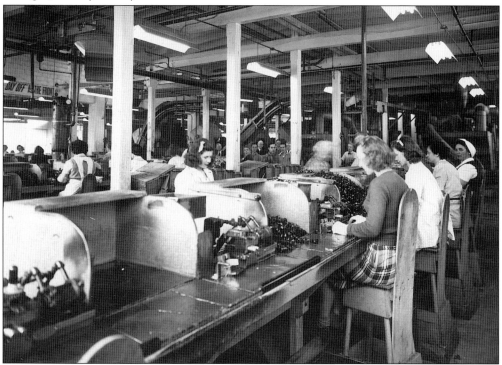

LADIES INSPECTING 50-CALIBER MACHINE GUN CARTRIDGE CLIPS. This photograph was taken during World War II at the Judd Company on South Cherry Street in 1943. Like many factories, the Judd Company retooled for war materials during World War II. Note the poster on the rear wall that says, "No Day Off At The Front."

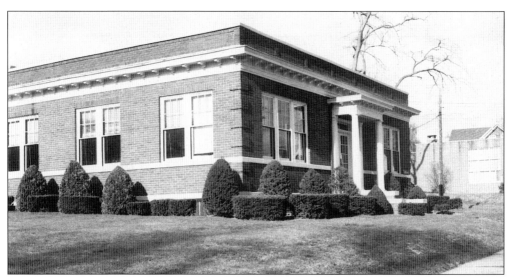

THE M. BACKES & SON OFFICE BUILDING ON S. ELM STREET ACROSS FROM THE YMCA, C. 1956. Started in the 1870s by Michael Backes, the company made torpedoes and caps in its early days, and later branched out into a wide variety of fireworks under the "Star" brand, which was well known throughout the country. Then, after a number of states banned fireworks, the factory was converted for making boxes.

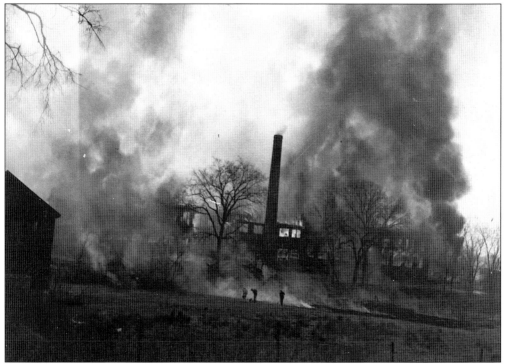

M. BACKES & SONS IN FLAMES ON THE WARD STREET EXTENSION, 1937. Dealing with fireworks and powder can be dangerous business, as can be seen here. This was the result of an explosion, perhaps in one of the storage sheds. There were a number of explosions through the years at this location.

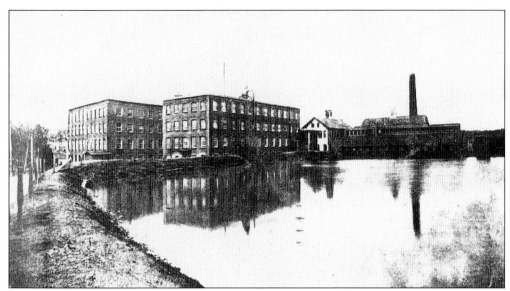

SIMPSON, HALL & MILLER, LATER FACTORY "L" OF INTERNATIONAL SILVER, C. 1922. The pond, sometimes referred to as Crystal Lake, and better known as Simpson's Pond, was used in earlier days as a source of power for the silverware mill.

PRODUCTS MADE OF "CATALIN" BY THE G.E. SEKOWSKI, CO., EARLY 1930S. Mr. Sekowski ran his tool and die shop at 18 South Orchard Street for a number of years into the 1930s. "Catalin" has a formaldehyde base and was a predecessor to the more modern plastics. Various household items such as bookends, candlesticks, and ashtrays were made from this substance.

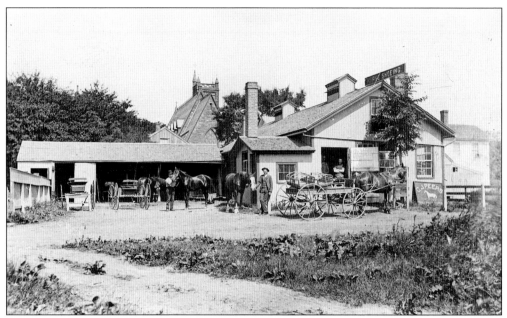

PEERS' BLACKSMITH SHOP ON WALLACE AVENUE, 1890. It looks like business was good the day this picture was taken. The shop was later owned by Mr. Tymeson. In the background is St. Paul's Episcopal Church.

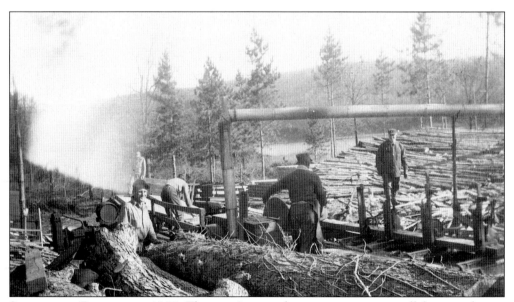

SAWMILL AT PISTAPAUG, 1937. The town's water department ran a sawmill for several years on the banks of Pistapaug, or Paug Pond. All the deciduous trees were taken down so that the leaves would not go into our largest reservoir. It certainly also provided additional income for the water department.

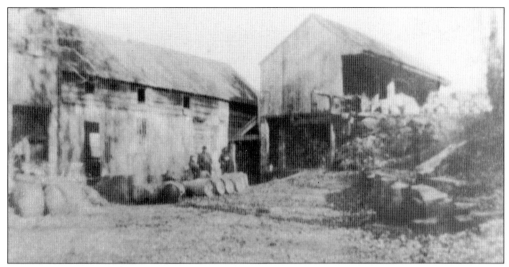

TYLER'S MILL, C. 1920. In the southeast part of town, where the Muddy River goes under Tyler's Mill Road, stood a lumbermill and a gristmill for well over 200 years. Until 1819, the mills were known as Peck's Mills, for founding planter Eleazur Peck and his descendents. Ezra Tyler bought the shares in the mills and the miller's house plus 180 acres between 1819 and 1826 for $945.

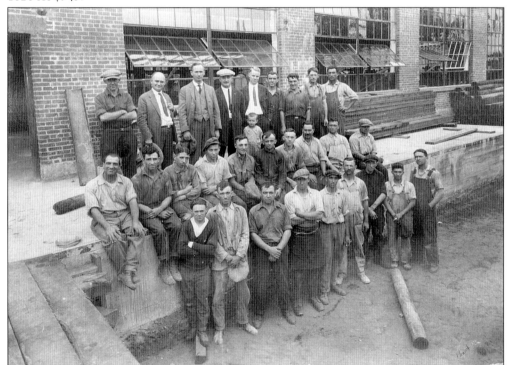

THE ORIGINAL EMPLOYEES AT THE WALLINGFORD STEEL COMPANY, 1922. In the back row, third from the left, is Gilbert Boyd Sr., co-founder and vice president, while fifth from the left is Edmund (Ted) Claiborne, co-founder and president. From this small beginning the company grew, so that in 1936 there were 221 employees. They were the first factory workers in Wallingford to be granted a week of paid vacation time.

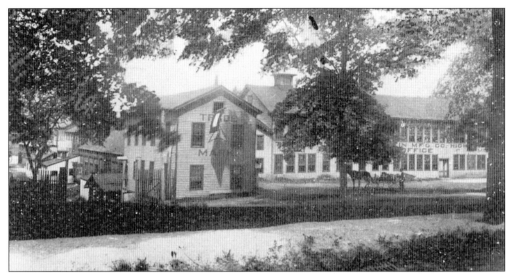

THE JENNINGS AND GRIFFIN MANUFACTURING CO. IN TRACY. This facility was built in 1880 by Charles E. Jennings and Francis B. Griffin for the manufacture of high grade tools such as the L'Hommedieu and Watrous ship augers, famous the world over. For a few years after World War II, it was part of the Stanley Tool Division, once again making augur bits. The building burned in 1948 in a spectacular fire.

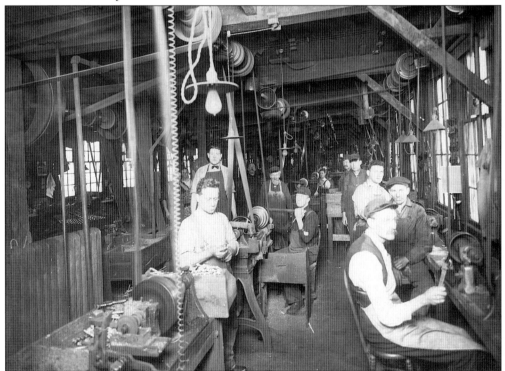

INSIDE THE JENNINGS AND GRIFFIN FACTORY IN THE EARLY 1900S. The workers seen here are probably working making drill bits or perhaps the "Arrowhead" tools, which were produced for many years. Business did slow after World War I as competition became keener, and the plant became idle. It was reorganized in 1939.

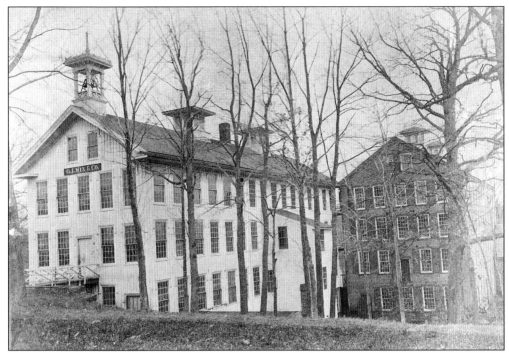

G.I. Mix & Company, Main Street, Yalesville. In 1854 Garry I. Mix started making britannia spoons, and later britannia and tin tea and coffee pots. From about 1810 and into the 1830s, John Mix, the father of G.I. Mix, manufactured bayonets near this site for the federal government as a subcontractor to Eli Whitney, who invented the cotton gin.

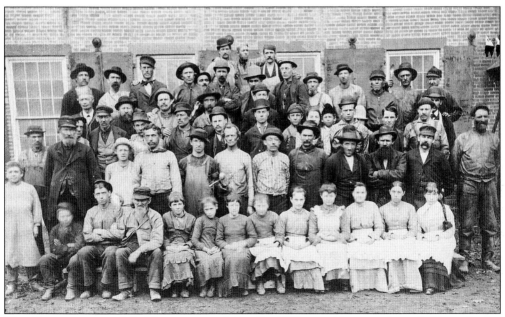

The Employees at G.I. Mix in the 1880s. By 1887, in addition to household goods, the company was making carpenter tools.

Five
Transportation

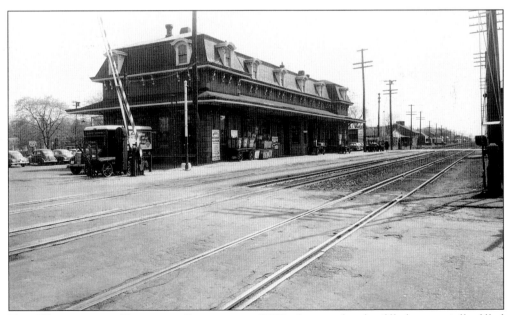

THE WALLINGFORD RAILROAD STATION, C. 1950. As seen by the filled or partially filled freight wagons, the station was an active facility. The truck at the left was a Railway Express vehicle, a business that no longer exists. In 1970, the station served as the hub of activities for Wallingford's tercentenary.

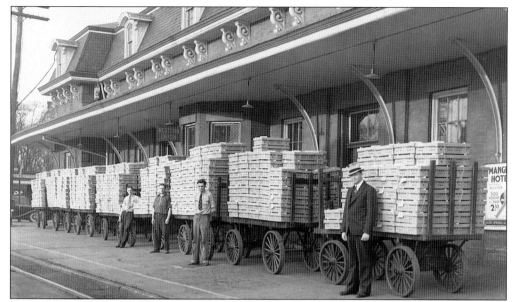

FREIGHT WAGONS FULL OF BABY CHICKENS, LATE 1930S. Hall Brothers Hatchery sent a shipment of this size almost every day by Railway Express. Hall Brothers was New England's largest baby chick hatchery and produced more than 16 million chicks in 1944. Al Yankus was the Railway Express foreman and Mike Cassella was the clerk at the time.

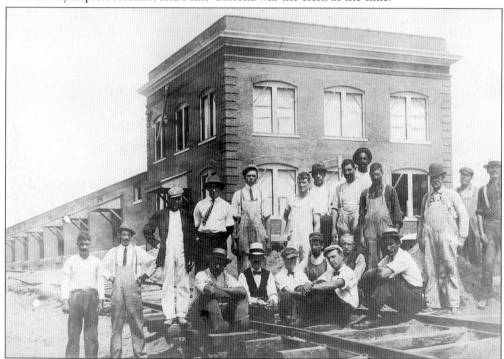

THE NEARLY COMPLETED FREIGHT STATION RUNNING ALONG NORTH CHERRY STREET, 1910. The H. Wales Lines Company was the contractor for this building. Please take note that several of the workers are wearing ties, and are also wearing coveralls to keep from soiling their clothes. They would remove the coveralls and put on suit jackets to go home.

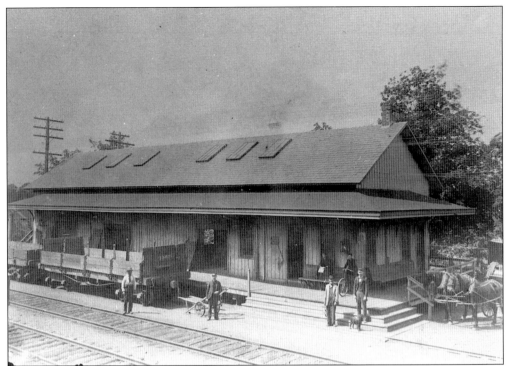

THE YALESVILLE RAILROAD STATION, LOCATED IN TRACY. This station was built in 1899. E. Carrington was the first agent, followed by W.E. Rice and C.W. Cook. It was torn down in 1939.

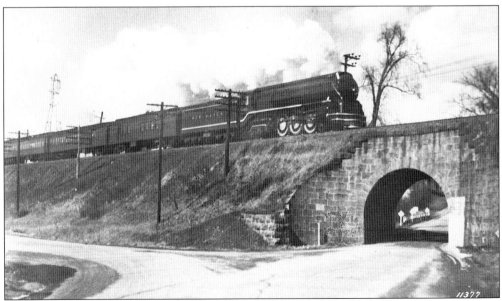

NEW I5 STREAMLINE LOCOMOTIVE AT HOLT'S HILL, 1939. This underpass is just to the east of the Yalesville Station. It was designed and built in 1841 by William MacKenzie, a Scottish stonemason who designed bridges for railroads throughout the northeast. The curve in the left foreground was known as "dead man's curve" because of all the accidents that occurred there.

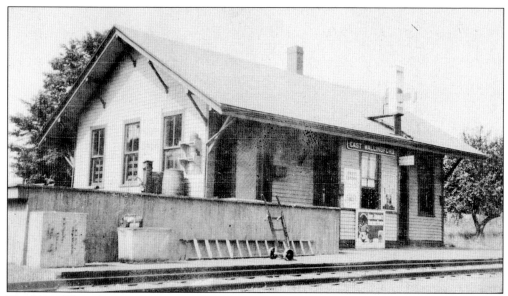

THE EAST WALLINGFORD PASSENGER STATION ON THE AIRLINE RAILROAD. This station, built in 1870, was closed in 1929 when passenger service was discontinued. It was sold a year later to Dwight Williams, who moved it back from the tracks. More recently it has been converted to a residence. The Airline, which ran between New Haven and Boston, was the shortest route between the two cities.

A RECEIPT FROM THE BOSTON AND NEW YORK AIR LINE RAILROAD, 1881. The price for shipping one box of potatoes, a hundredweight, from Boston to Wallingford was 75¢. The potatoes came in to the freight station on the north side of East Center Street, now the location of Peter Fresina's carpentry shop.

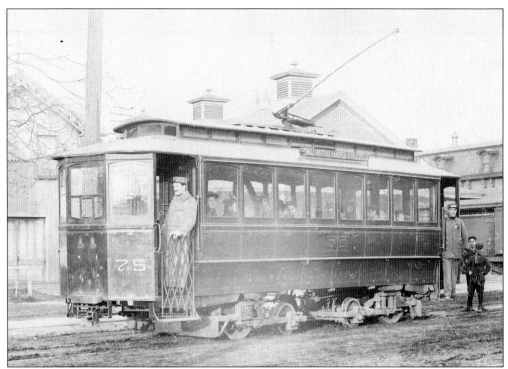

THE MERIDEN TROLLEY AT THE WALLINGFORD DEPOT. This trolley ran from the west side of the New York, New Haven and Hartford Railroad up into Meriden. The old freight terminal can be seen at the left.

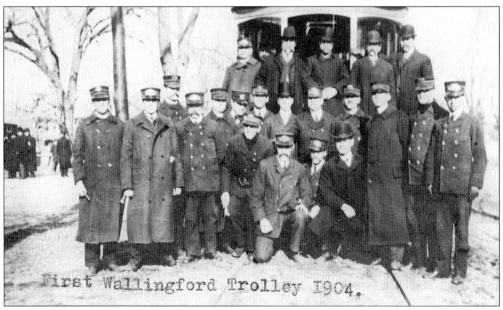

THE FIRST WALLINGFORD TROLLEY RUN, 1904. The first run of the Wallingford Tramway between Wallingford and New Haven was in 1904. This picture was taken at Dutton Park, the most northerly point of the line in town.

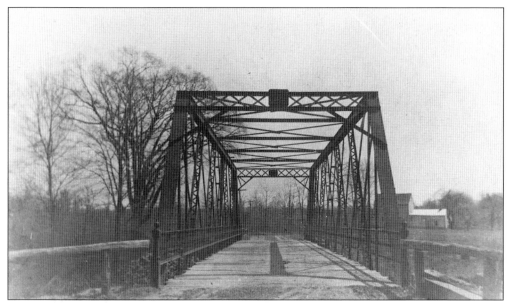

THE STEEL WARREN-TRUSS BRIDGE SPANNING THE QUINNIPIAC RIVER. The Pestey farm is visible in this view looking east on Toelle's Road from the west end of the bridge, which was built by the Berlin Iron and Steel Company in 1898.

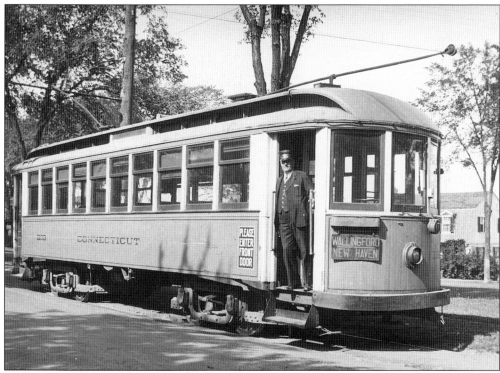

THE WALLINGFORD-NEW HAVEN LINE AT DUTTON PARK, JUNE 8, 1934. Taken on the east side of the park, you can almost hear the conductor say, "All aboard!" This line operated until 1937. Prior to its closing, it was the best way to travel to New Haven, where you could then change trolleys to spend a day at Savin Rock in West Haven.

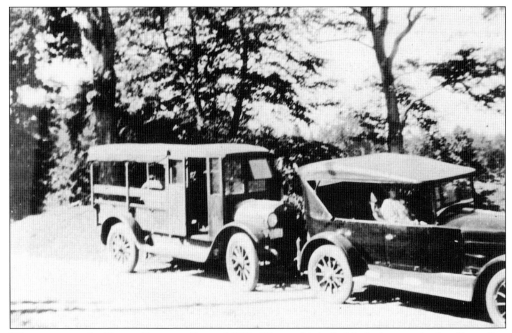

WALLINGFORD'S FIRST SCHOOL BUS, 1923. The vehicle behind the car is the Rose Bus Company's first school bus. This was basically a truck with two benches in it. There were curtains on the sides, which could be closed if it rained or snowed. In the winter, if there was too much snow, a two-horse sled with runners was employed. It had hay on the floor and blankets to keep you warm.

HOWARD ROSE AS A STUDENT. Howard's father owned the first school busses in town, and Howard was one of the first drivers. He later owned the company for over 40 years. For most of that time, it was the only bus company in town.

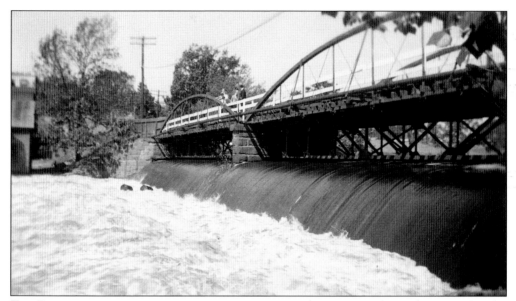

THE DOUBLE-BOW BRIDGE ON HALL AVENUE, 1938. This picture, taken a day or so after the hurricane of that year, shows water rushing over the 12-foot-high dam that held the water in Community Lake.

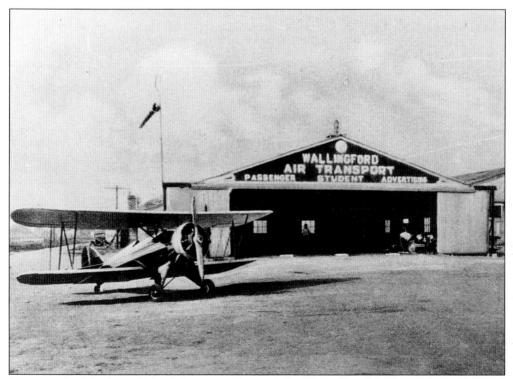

LUFBERY AIRPORT, C. 1930. The airport, named for Major Raoul Lufbery of World War I renown, served many people interested in flying from the 1920s through the 1940s. One of the hangars is still used as a storage building by the Wallingford Electric Division at the corner of John and East Streets.

Six
BENEFICENT WALLINGFORD

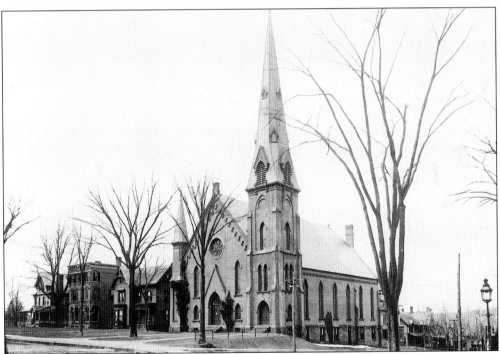

THE FIRST CONGREGATIONAL CHURCH, C. 1905. This is the fifth church on this site. The original meetinghouse was the spiritual home to Rev. Samuel Street, the first minister in Wallingford. The First Church Society, as it was known for many years, prospered as the town grew until this fine building was constructed in 1869 at a cost of $40,000—no small amount at that time. At the right front take note of the gas lamp, which was provided by the Wallingford Gas Light Company.

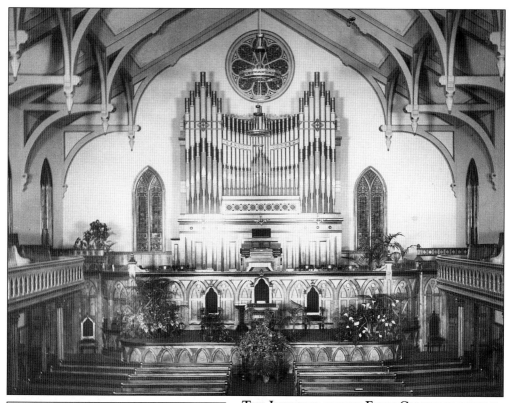

THE INTERIOR OF THE FIRST CONGREGATIONAL CHURCH. This is how the church looked after the organ and pipes were moved in 1890. An addition was made to the west end of the church to accommodate the move. The organ was powered by water, which was a great step forward.

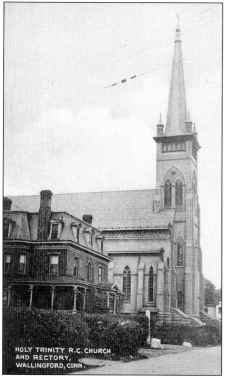

THE HOLY TRINITY CHURCH AND RECTORY. The cornerstone of this fine edifice was laid on September 24, 1876. Father Hugh Mallon oversaw the building of the church; when construction slowed because brownstone was not arriving quickly enough from the Portland quarry, he provided some of the necessary stone from his property on East Main Street.

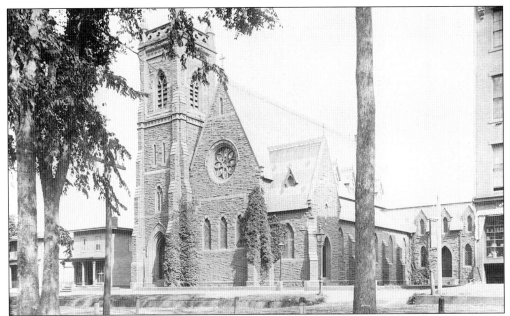

ST. PAUL'S EPISCOPAL CHURCH, BUILT IN 1868–69. This building replaced an earlier church, which burned in 1867 in the same fire that burned Union Hall. Moses Beach along with Samuel Simpson helped to provide the funds for the reconstruction. The brownstone came from Portland.

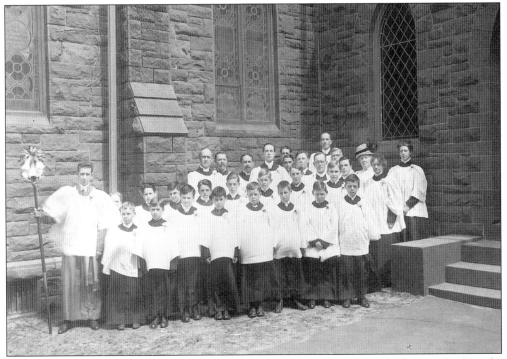

ST. PAUL'S CHURCH CHOIR READY FOR EASTER SERVICES, C. 1925. The lady at the far right is Jennie Munson; to her right, with the hat, is Edith Pogmore Smith. Wearing glasses in the third row, third from the right, is Rev. Arthur P. Greenleaf.

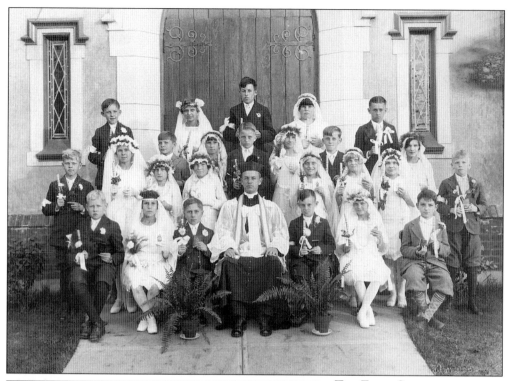

THE FIRST COMMUNION CLASS AT ST. PETER AND PAUL CHURCH ON NORTH ORCHARD STREET, C. 1925. Father Alexander Tanski officiated as the first group of parish children made their first communion.

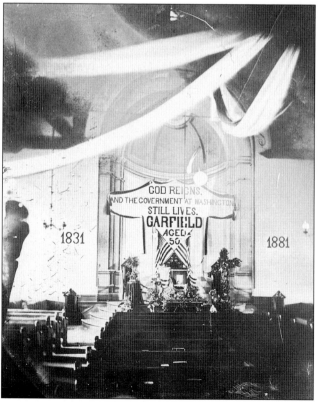

THE INTERIOR OF THE FIRST BAPTIST CHURCH DECORATED IN MOURNING FOR PRESIDENT JAMES A. GARFIELD IN 1881. The president, after only serving a few months, was shot at Union Station in Washington, D.C., by Charles Guiteau, who had failed to be appointed as the U.S. ambassador to France.

THE FIRST BAPTIST CHURCH AND THE FIRST UNITED METHODIST CHURCH AT CHURCH AND NORTH MAIN STREETS. The Baptist church was built in 1871 for $39,000. To the right is the Methodist church, which suffered fire damage and was replaced by the current church on New Rock Hill Road.

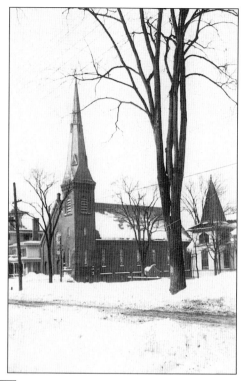

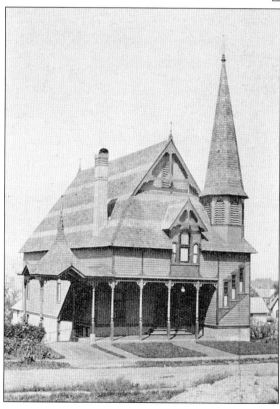

THE ADVENT CHRISTIAN CHURCH, DEDICATED ON FEBRUARY 4, 1891. Prior to the construction of this fine wooden building on North Whittlesey Avenue, church services were held for more than a decade on the second floor of the South Main Street School. Although small in numbers and finances, the Adventists started the building fund in early 1890, and were able to pay off the debt they owed on their church by the end of 1892.

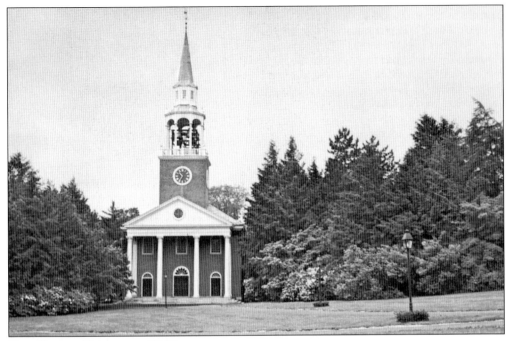

THE CHOATE CHAPEL, C. 1960.

ELKS CLUB FOOD BASKETS READY FOR DELIVERY TO THE NEEDY, DECEMBER 1933. The Elks occupied the Judd Mansion on South Main Street next to Lyman Hall High School at this time.

THE COMMUNITY HOUSE, c. 1880. The Wallingford branch of the Oneida Community was founded by Henry Allen in 1851. Allen and his family were ex-communicated by the Congregational Church for following the "Communistic" teachings of John Humphry Noyes. They were a well-to-do company of hard-working people. In addition to farming, the Oneida Community ran the Mt. Tom Printing Company. The making of iron spoons, commencing in 1870, developed into the Oneida Silver Company.

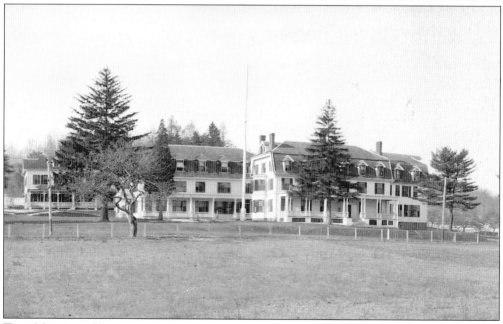

THE MASONIC HOME AND ORPHANAGE, 1915. The Oneida Community property was purchased in 1894, took in its first admission in May of 1895, and was dedicated on September 25, 1895. It started with two buildings equipped with 32 sleeping rooms, and, by the end of the first year, had 18 "inmates," as the residents were called then.

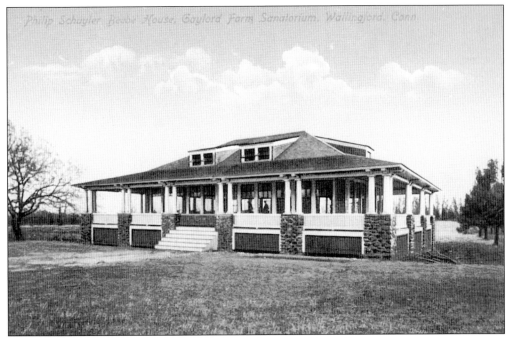

THE PHILIP SCHUYLER BEEBE HOUSE AT THE GAYLORD FARM SANATORIUM.

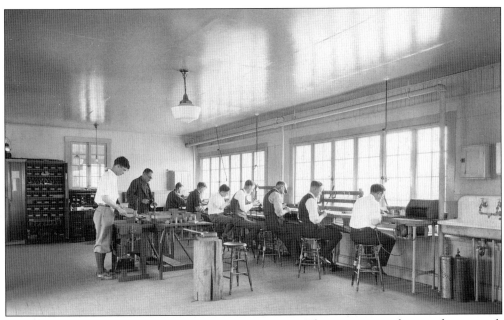

THE GAYLORD SANATORIUM SILVER SHOP, C. 1930. The sanatorium, known for its work with tuberculosis patients, took in some veterans who had been gassed in World War I. The government paid for the equipment to train the men in the silver trade. The men, under the guidance of Alvin Masonville and Joseph Demonda, took the silver blanks and with leather hammers would form the silverware in the "Gaylord" pattern. After 1950, Michael Robinson, a former patient, supervised the work therapy program.

Seven
Special Occasions and Entertainment

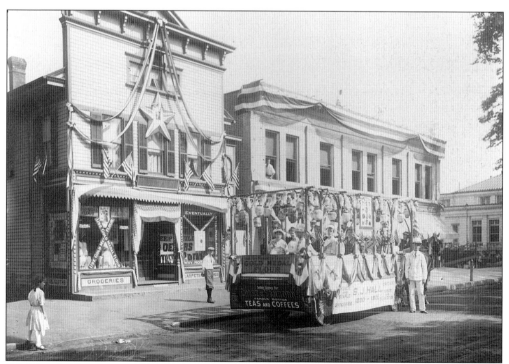

S.J. Hall's Float in the 1911 July Fourth Parade. The float represented a Japanese tea party, and was sponsored, in part, by the makers of the famous Boston Teas and Coffees. Sidney Hall ran a very successful grocery and dry goods store at this location for over 30 years.

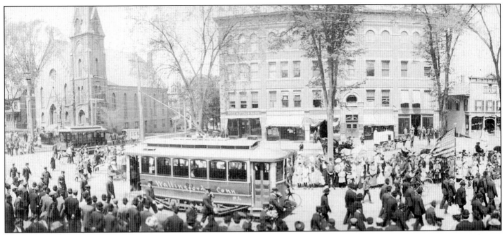

"I LOVE A PARADE." This picture postcard of Main and Center with Simpson Court, from about 1910, gives us a good sense of how the Wallingford of 90 years ago enjoyed celebrating with a parade. In addition to the units in the parade, there are many items to note—the New Haven trolley, the "Dinky" (the Center Street trolley), an ice wagon, a "covered" wagon, and more.

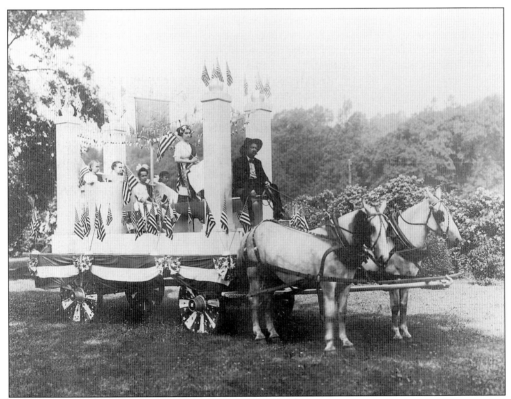

THE R. WALLACE & SONS MANUFACTURING CO. FLOAT, JULY 4, 1911. The seating arrangement and design were meant to resemble a large silver spoon. Teaspoons were strung on wire, and the four pillars at each corner were topped with American flags.

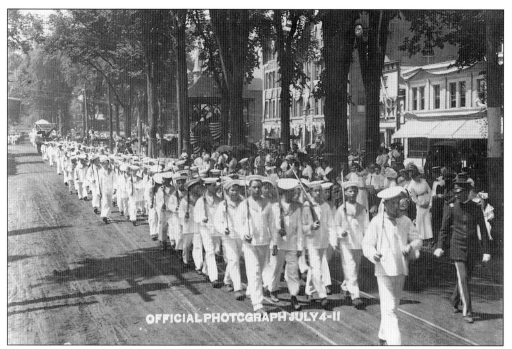

THE INDEPENDENCE VOLUNTEERS, JULY 4, 1911. Dressed in naval uniforms, schoolboys from the Colony Street and Whittlesey Avenue Grammar Schools march up Main Street to celebrate our independence. The gentleman to the right is the school principal, James E. McCabe. Note how the street is lined with stately elm trees, now a thing of the past.

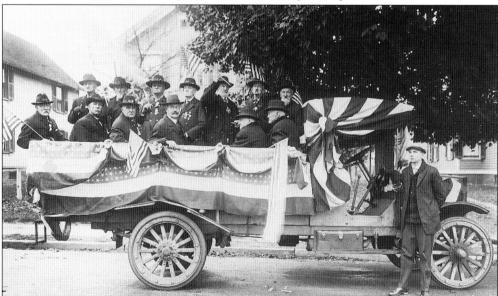

THE GRAND ARMY OF THE REPUBLIC FLOAT ON LYMAN HALL DAY, OCTOBER 19, 1916. Thirteen of the veterans, who had fought in the Civil War over 50 years earlier, rode in the back of C.L. McLean's Local Express truck over the course of the parade route. Each one carried an American flag. It was probably not a very comfortable ride, as the truck had solid rubber tires.

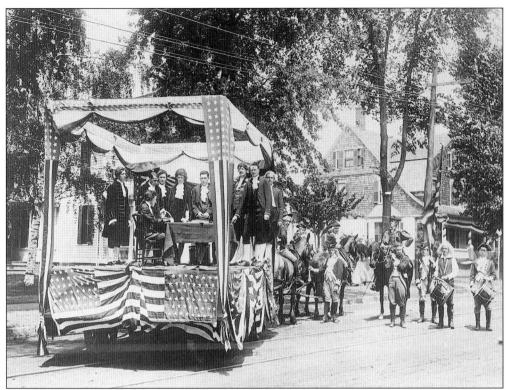

A Float with Lyman Hall Signing the Declaration of Independence, October 19, 1916. The gentleman playing the part of Lyman Hall was Almon E. Hall. The float was on North Main Street just south of High Street. The parade, with over 1,000 marchers, 15 floats, and 60 autos, went its full course despite being dampened by inclement weather.

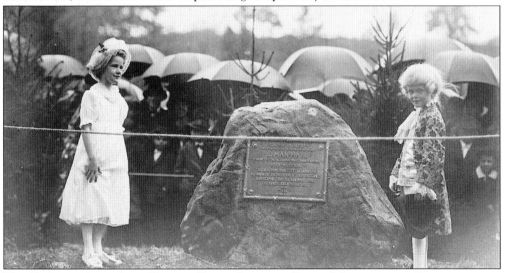

The Dedication of the Bronze Tablet on the Stone Marking the Birthplace of Lyman Hall on South Elm Street. After the parade, and following speeches by Connecticut Governor Marcus E. Holcomb and Dean Charles D. Brown of Yale, the dedication took place in spite of the rain.

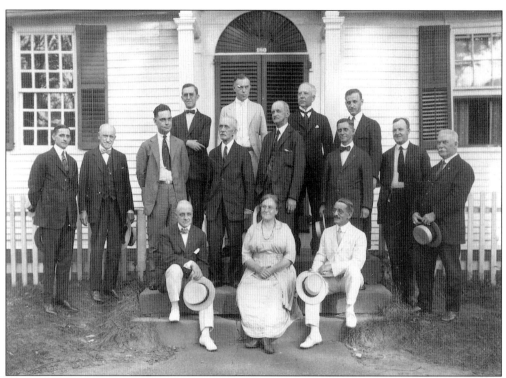

THE CELEBRATIONS COMMITTEE FOR WALLINGFORD'S 250TH ANNIVERSARY AT THE PARSON'S HOUSE, 1920. The committee members are, from left to right, as follows: (front row) Charles G. Phelps, Mrs. G.H. Craig, and John R. Cottrill; (middle row) L.V. Hall, C. Storrs Hall, H.F. Penniman, Marshall Kirtland Thomas, O.H.D. Fowler, William Bertini, J.J. Kane, and John G. Phelan; (back row) E.C. Cox, H. Winter Davis, Marc B. Sanders, and Vere T. Bahner.

JEAN CARROLL HOLLOWAY AT THE 250TH ANNIVERSARY PARADE IN SEPTEMBER 1920. Jean is wearing a dress worn by George Trumbull Jones when he was baptized in 1861. Her carriage, decorated with hydrangea blossoms, won first prize in the parade.

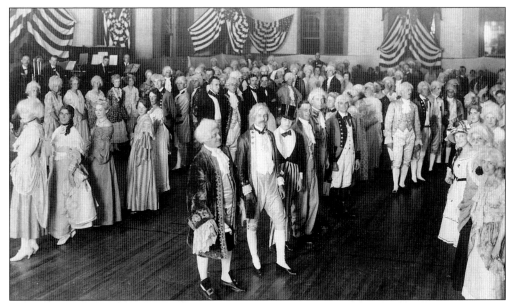

WALLINGFORD'S 250TH ANNIVERSARY BALL, 1920. Everyone seems to have gone all out with their formal late-1700s attire for the ball, which took place in the Choate Gym.

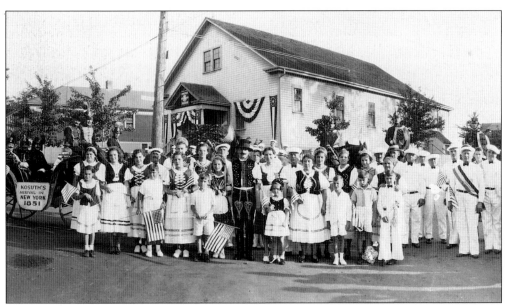

THE HUNGARIAN COMMUNITY CLUB GETTING READY FOR THE 1935 CONNECTICUT TERCENTENARY PARADE IN FRONT OF THE CLUB'S HALL ON THE CORNER OF WARD AND CLIFTON STREETS.

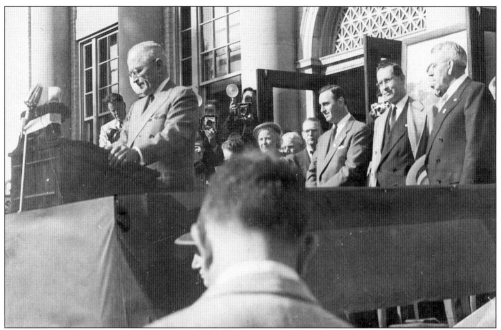

PRESIDENT HARRY S. TRUMAN SPEAKS ON THE STEPS OF LYMAN HALL HIGH SCHOOL, C. 1950. Behind the President are Mrs. John McGuire, wife of Congressman John McGuire, Town Assesor Louis Isakson, Congressman Abraham Ribicoff, an unidentified man, and Second Selectman Albert Roberge. It was an honor to have a sitting president come to town.

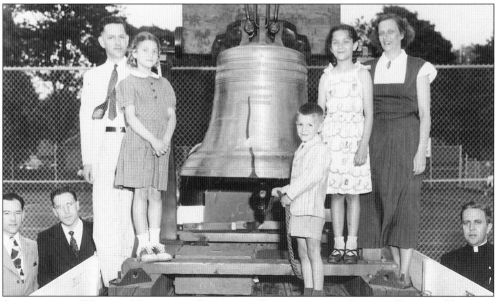

SIX-YEAR-OLD WILLIAM MACKENZIE RINGING A REPLICA OF THE LIBERTY BELL TO KICK OFF A SAVINGS BOND DRIVE AT DOOLITTLE PARK, 1950. Bill, an eighth-generation descendent of Giles Hall, the brother of Lyman Hall (who signed the Declaration of Independence), is shown here with his parents, William Neal and Edith Mackenzie, and his sisters Margaret and Mary. The others in the photograph are Master of Ceremonies Emil Faubert, Rev. Delwin Lehmann, and Rev. Zoltan Kish.

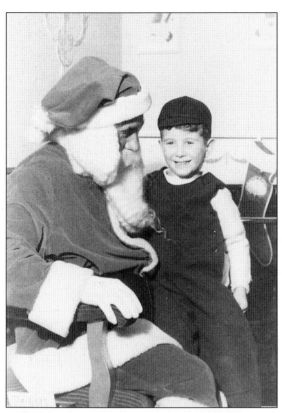

JIM GANNON, AGE FOUR AND A HALF, VISITING WITH SANTA CLAUS, CHRISTMAS 1947. What he didn't realize is that he knew this Santa very well. It was his father, Robert Gannon.

SANTA WAS A LADY? About 1930, Mrs. Hattie A. Brown, Hattie Wardle at that time in her life, would dress up as Santa Claus every year for her nieces. She also played Santa for some of the lodges in town. Did you ever see Santa with such an engaging smile?

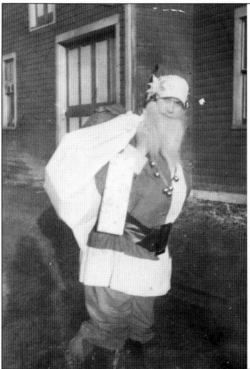
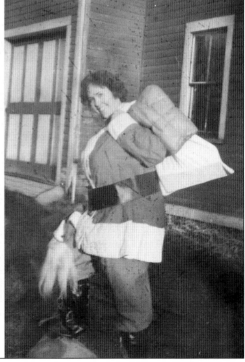

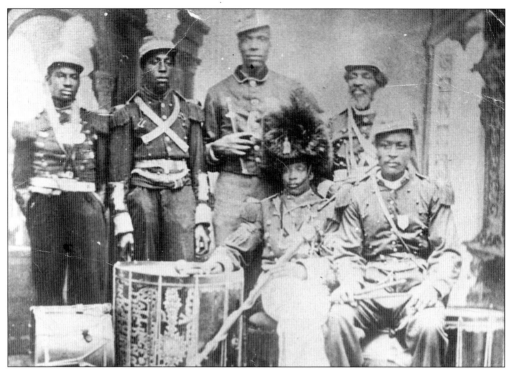

THE DRED NOTS. William P. "Tony" Smith, at the far right, was a veteran of the Civil War in Company F of the 54th Massachusetts Black Regiment and was the organizer of this drum corps in 1872. The men in the corps are, from left to right, unidentified, Gene Smith, Burt Gifford, Burt Walmsley, George Washington Broadwell, and William P. Smith.

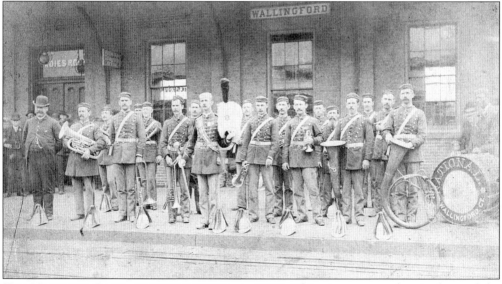

THE NATIONAL BAND OF WALLINGFORD, C. 1890. This picture was taken in front of the Wallingford Railroad Station. The band played at many patriotic functions from the 1880s to about 1910.

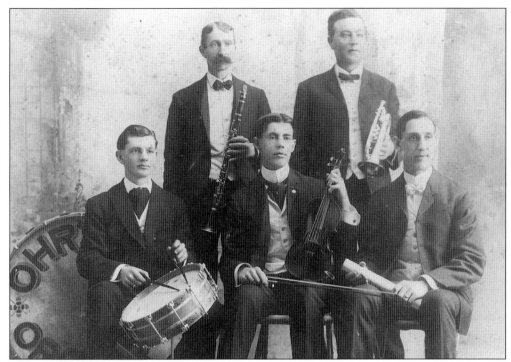

THE JOHN OHR ORCHESTRA, C. 1900. John is the violinist in the center of the front row. His brother, Edward Ohr, is the drummer to his right, while in the back on the right is Harry Penniman on trumpet.

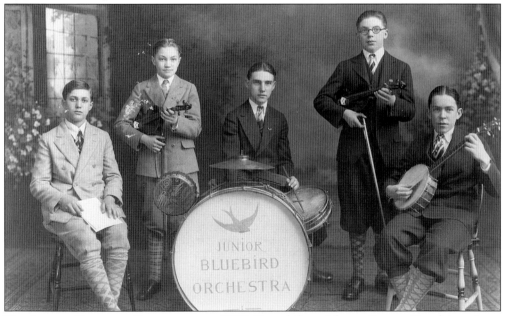

THE JUNIOR BLUEBIRD ORCHESTRA, C. 1926. From left to right are Eugene Dauplaise, piano; Rolly Bundock, violin; Bob Gannon, drums; George Grasser, violin; and Bob Leonard, banjo. While the others became prominent local residents, Rolly became a successful musician with Hal McIntyre, Glenn Miller, Tennessee Ernie Ford, and the NBC Symphony Orchestra.

Opera House Program

SEASON 1900-1901 WALLINGFORD, CONN., NOVEMBER 28, 1900 G. H. WILKINSON, MGR

HI. HENRY'S BIG MINSTRELS.

ORGANIZED IN NEW YORK CITY.

Presenting for the first time on any stage our own new, original and elaborate

FIRST PART.

The Bachelor's Club.

(ANNIVERSARY PERFORMANCE.)

LEFT.	CENTER.	RIGHT.
T. Harry Belknap	J. Albert Gates	Jno. Dove
Jas. Corrigan		Harry LaRue

PREMIERS.

J. C. HARRINGTON FRANK MITCHELL
Director of Music Mr. HI. HENRY

SCENIC EFFECTS, M. ARMBRUSTER, Columbus, O.
COSTUMES, W. KRAUSE & SON, Cleveland, O.
GOLD CORNETS, SAXAPHONES, GOLD TROMBONES, INLAID VIOLINS, VIOLA, CELLO AND BASS,
By C. G. CONN., New York City and Elkhart, Ind.

Program Continued on Second Page.

POST'S
TRADE MARK
ANTISEPTINE

For Cuts, Burns, Scalds, Bleeding and Itching Piles, Running Sores and Ulcers.
A sure Preventive and Cure for Blood Poisoning and Inflammation.
For Sore Throat, Inflamed Tonsils and Canker, use as a Gargle.

PREPARED BY
ANTISEPTINE CO.,
Wallingford, Ct.

PRICE 25 CENTS.

SHERWOOD & SON,

Wallingford Department Store.

INTRODUCTORY

We don't pay for this space for fun or to help the publishers. Its a way to introduce you to our store, our business. We want you to know more about this Department Store—The Why's, Etc.

This kind of a store is new for Wallingford. Its the old-time way of keeping store—selling everything. The difference is the management—each department separate.

We Have Been jumped on many times. Our way don't suit some—(storekeepers)—It requires too much hustle to suit them. They prefer to smoke 25 cent cigars and sit in easy chairs. This don't work in a Department Store. The people don't allow it.

We Still Live. This Department Store way of doing business is free to all, all have the same field. Just try it.

What We Sell is what people want. Anything, everything, for everybody. We try to save you a little on every item you buy. All we ask is for you to call in and look around. We hope you will enjoy the visit. We have spent many dollars to make this store attractive.

SHERWOOD & SON,
126 CENTER STREET.

Telephone, Wallingford 449-2
" Meriden 87-3.

When you come to Meriden call and see us. Five stores, West Main Street.

C. H. GLAVE, MERCHANT TAILOR AND MEN'S FURNISHINGS.
Nobby patterns and latest styles always in stock. Drop in and see for yourself. All are welcome at **44 CENTER ST.**

GEORGE WILKINSON'S OPERA HOUSE PROGRAM, NOVEMBER 28, 1900.

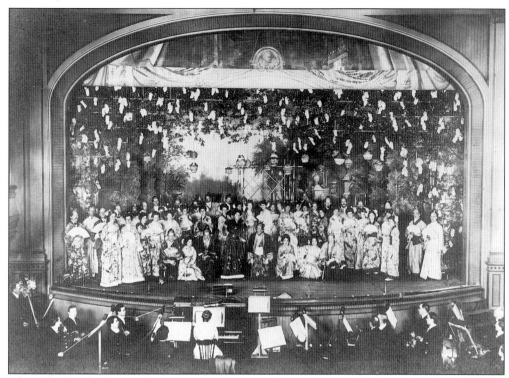

THE 1911 PRODUCTION OF GILBERT AND SULLIVAN'S *THE MIKADO*. This production was among the many moments of splendor at the Wilkinson Opera House. The dress rehearsal is recalled in this picture. The entertainment center occupied the third and fourth floors of the former Dime Savings Bank.

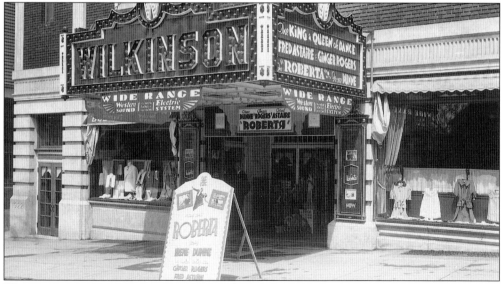

WILKINSON'S THEATER, C. 1938. Times change—in 1922, Mr. Wilkinson built this motion picture theater with room for two retail stores, Cahill's Annex on the right and Bob Houlihan's on the left. To this day, people still remember Mrs. Wilkinson, who was the ticket seller for many years.

ONE OF THE FINEST SINGING VOICES TO COME OUT OF WALLINGFORD. Morton Downey, a fine Irish tenor, was brought up on South Orchard Street and was a choirboy at Holy Trinity Church. By the early 1920s, he was a soloist with the Paul Whitman Orchestra. He later sang with Fred Waring's Pennsylvanians. His theme song on his radio show was "Carolina Moon."

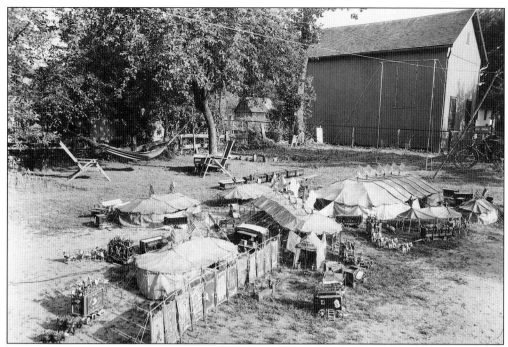

THE CIRCUS IN MINIATURE. Bill Brinley, who loved the circus, made it his hobby by building it in miniature. Although it would, in later years, be on display for the public in such places as the P.T. Barnum Museum in Bridgeport, the tents and the midway were erected in Mr. Brinley's backyard on Wallace Row this nice summer day.

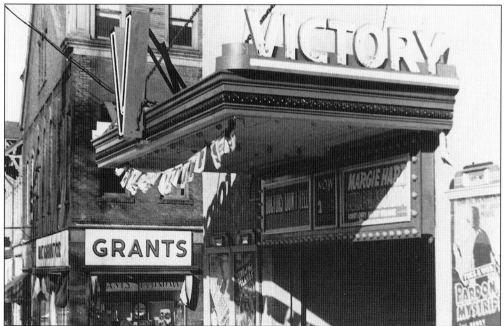

THE VICTORY THEATER DURING WORLD WAR II. To avoid competition, George Wilkinson reopened the movie house at Center and North Orchard Streets so that he would not have someone else competing with his own theater, which was just up the hill.

Eight

WALLINGFORD UNDER SIEGE BY MOTHER NATURE

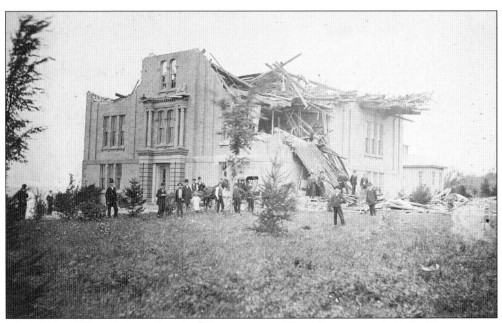

THE NORTH MAIN STREET SCHOOL/WALLINGFORD HIGH SCHOOL AFTER THE TORNADO OF AUGUST 9, 1878. After a few seconds in the funnel of the tornado, the school lost its top two and a half floors. Luckily, this occurred in the summer when school was not in session (see p. 33 for a view prior to the storm).

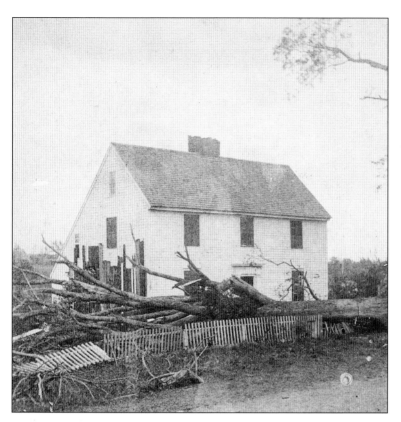

COMPARATIVELY UNSCATHED. The Peck House, located directly across from the school, on the corner of North Main and Christian, only lost some shingles and part of the fence on Christian Street. Forty years later it was moved to North Orchard Street, to the rear and south of the St. Peter and Paul Church. It sits there today as a fine example of a mid-1700s saltbox.

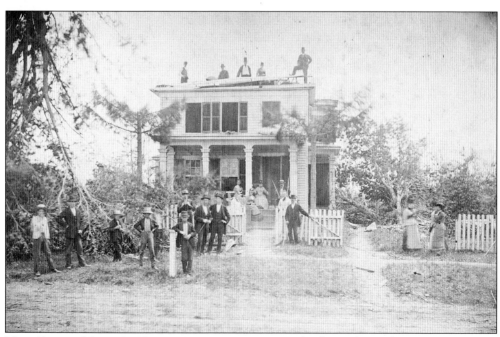

MRS. FRIEND MILLER'S HOUSE, 393 MAIN STREET. This house lost only its roof and attic. Mrs. Miller was fortunate compared to John Munson's house next door (see the facing page).

JOHN MUNSON'S HOUSE AT 387 NORTH MAIN STREET. This nice Dutch Colonial had its second floor blown into the street and was virtually totally destroyed. After the storm, four family members were taken from out of the rubble in the cellar with only slight injuries.

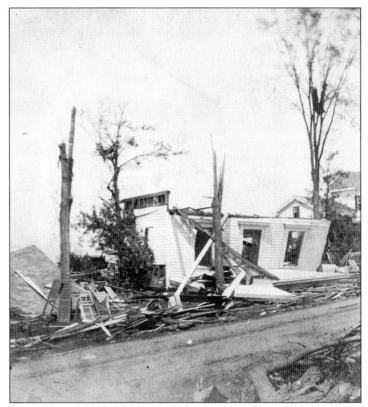

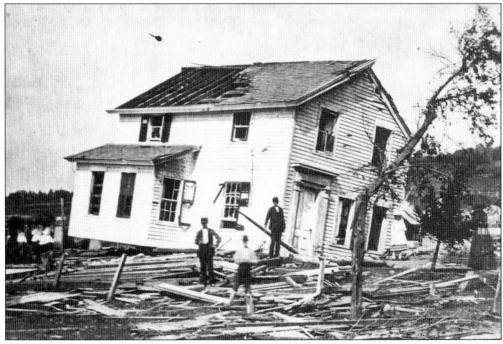

JOHN GINTY'S HOUSE ON HIGH STREET. This house suffered damage to its roof and was knocked off its foundation, but appears relatively unharmed beyond that.

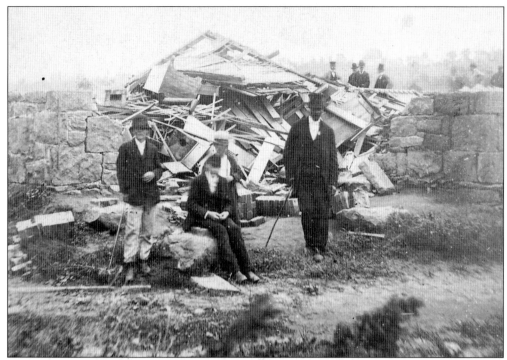
THE CATHOLIC CHURCH NEAR THE CEMETERY ON NORTH COLONY STREET. This storm may have helped with the decision to build the much bigger Holy Trinity Church down the street.

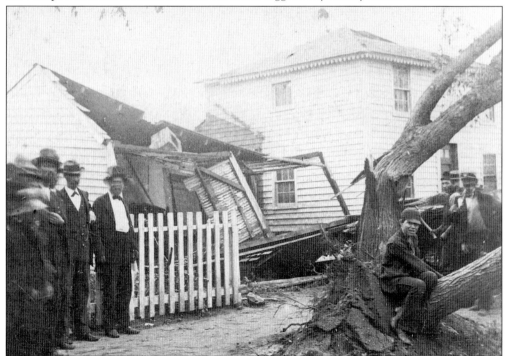
TOM WRYNN'S HOUSE, NEXT TO THE CHURCH ON COLONY STREET. This house, at the corner of Parker Street, was destroyed, yet the one next door appears to be fine.

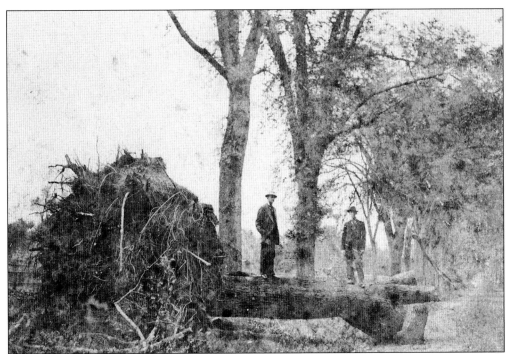

AN ELM TREE AT THE CORNER OF ELM AND ACADEMY STREETS, 1878. When you consider that most of the damage was two or more blocks to the north, it is surprising that this tree came down.

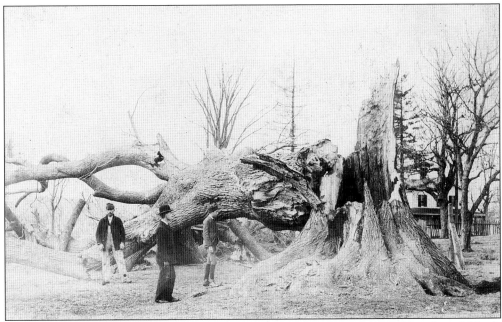

THE WASHINGTON ELM BLOWN DOWN, 1896. The elm, at the corner of North and North Main Street in front of the Royce House (before it was moved), came down in a freak wind. The story goes that President George Washington stood under this tree in 1789 when bidding the townspeople goodbye.

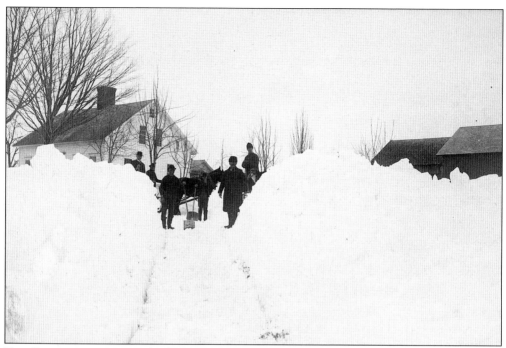

THE BLIZZARD OF 1888. The location is unknown, but try to imagine the effort these fellows put in to make the path clear by shovel.

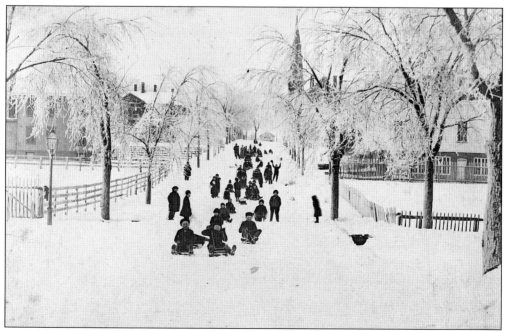

A CHURCH STREET SNOW SCENE. The Baptist church is in the background. Take note of the gas light to the left.

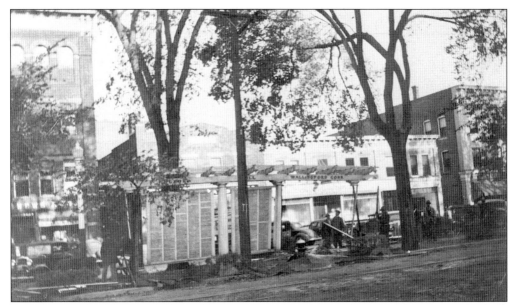

THE WORLD WAR I MEMORIAL AT SIMPSON COURT, SEPTEMBER 1938. The memorial, which listed all the veterans of World War I, was partially blown down by the Hurricane of 1938. The names had been painted on the boards by Rev. Henry Stone, the minister of the Advent Church. The following year a more permanent monument was dedicated.

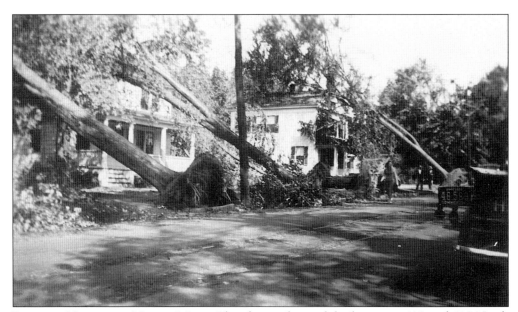

LOOKING NORTH ON NORTH MAIN. The elms in front of the houses at 412 and 418 North Main, the homes of Howard Lane and Joel Barnes, were some of many that fell during the hurricane.

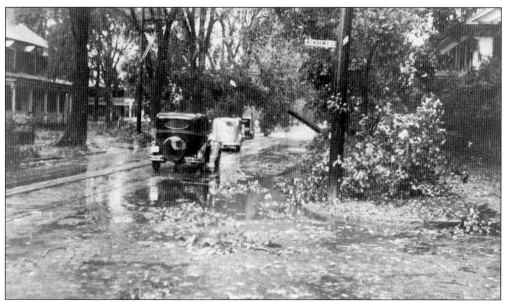

DRIVING UP NORTH MAIN STREET ON THE DAY OF THE HURRICANE. Just north of the intersection of Academy and North Main was a temporary overpass due to a tree tilting across the street. It looks like the two cars are planning to drive under it.

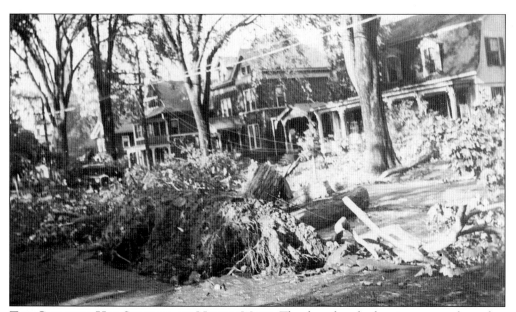

THE CLEAN UP HAS STARTED ON NORTH MAIN. The day after the hurricane, a pathway has been cleared in front of Dr. Gushee's house at 187 North Main Street.

Nine
AROUND THE TOWN

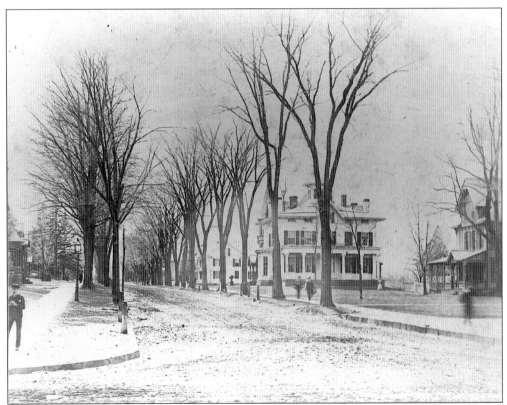

THE JARED WHITTLESEY HOUSE, C. 1885. This photograph was taken looking down South Main from Center Street. The large house to the right of center is Mr. Whittlesey's. To make his lot more spacious, Mr. H.L. Judd (see p. 101) bought the house and moved it to the corner of Prince and South Whittlesey, where it later became home to the Owenoco Tribe of the Improved Order of Redmen.

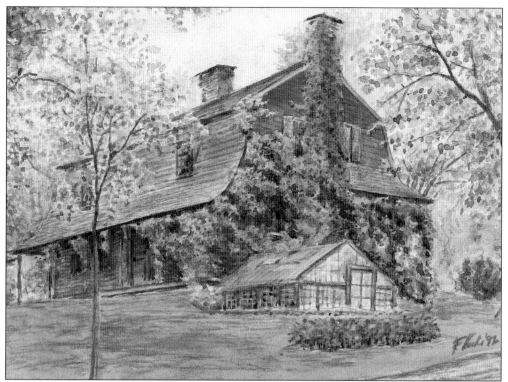

THE ATWATER COTTAGE/STORE, C. 1892. This is the second house east of North Elm on Christian Street, and is now home to one of the Choate faculty. It was Caleb Atwater's store when George Washington stopped to buy gunpowder on his way to take charge of the Continental Army in 1775. The image is from an original watercolor by F. Lasko done in 1892.

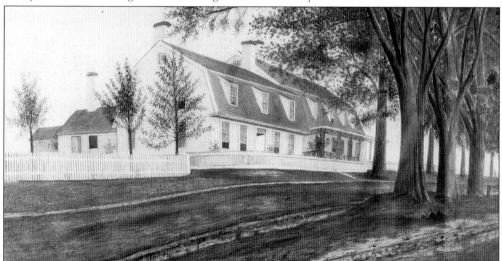

THE SQUIRE OLIVER STANLEY HOUSE, 1855. The house where George Washington dined after his business at the Atwater's Store is shown here in a copy of a painting by C.K. Hall. Note how there used to be a row of trees down the middle of Christian Street. In more recent years the house, where Choate School was started in 1896, has been used as a visitors center for the school.

AN OUTING ON PARADISE ISLAND IN COMMUNITY LAKE, 1889. On many a fine summer day people would board the *Starlighter* for a short cruise to the pavilion on Paradise Island.

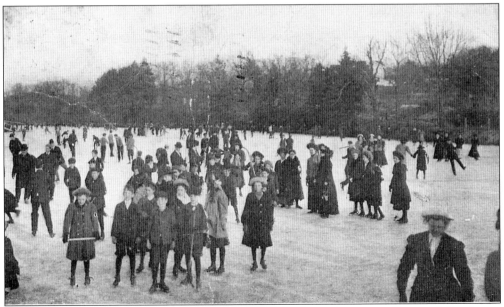

SKATING ON CRYSTAL LAKE, EARLY 1900S. The lake, better known as Simpson's Pond, was the mill pond associated with Simpson, Hall & Miller. It was used for recreational purposes and, prior to 1897, as a source of ice for several ice companies.

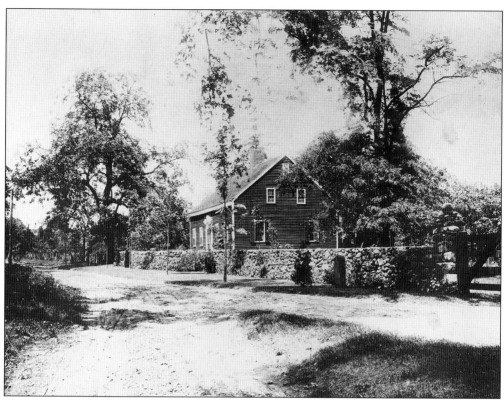

THE ROSE FARM, BUILT IN 1720. The house is located on Mansion Road, but no longer has the well-built and well-maintained stone wall.

THE COLONEL WILLIAM MARKS HOUSE, LATER THE ROSE HOUSE, LOCATED ON MANSION ROAD, ACROSS FROM THE BUS BARN. The main part of the house, built in 1820, was attached to the old house, which was 100 years older. The well had been in the center of the shed until it ran dry. There appears to be a good crop of cabbages in the foreground, across the road from the house. The well and the shed were removed more than 50 years ago.

THE THEOPHILUS JONES HOUSE, BUILT IN 1740. This fine example of a wealthy farmer's house remained in the Jones family for five generations. By 1880, the property was comprised of over 1,000 acres, which included three barns and a cider mill. The house was restored by Charles Montgomery, a distinguished scholar of American decorative arts. For its architectural integrity and its historical significance, the house is listed on the National Register of Historic Places.

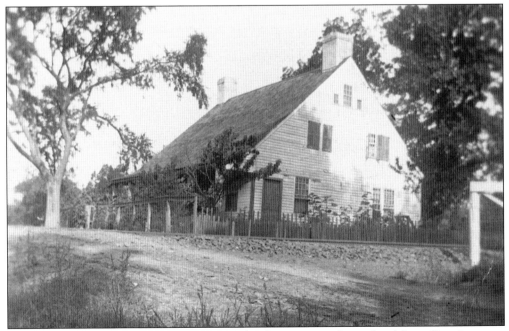

THE MORSE HOUSE, BUILT ABOUT 1800. This fine cape was located at Morse Crossing, now known as Toelle's Road. The railroad tracks were just a few steps from the front door. After enduring countless trains through the years, it eventually burned down.

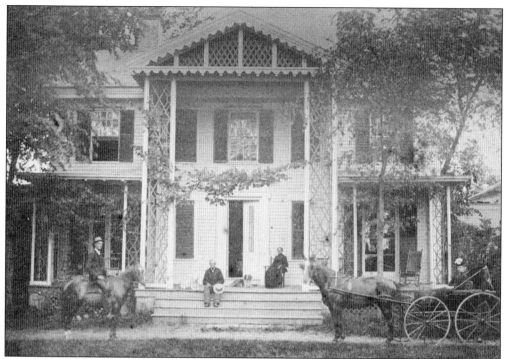

THE OAKDALE TAVERN IN THE EARLY 1900S. Built in 1769, this was later the home of Peter Jones. It was known as the Oakdale Tavern for over 80 years. This was demolished in 1996.

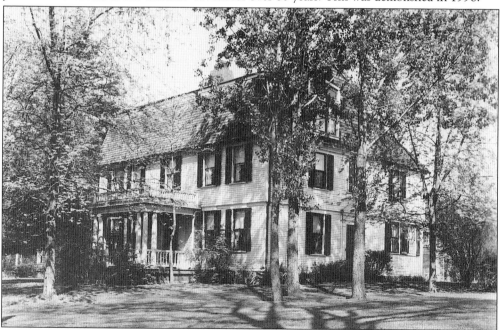

THE DANA HOUSE. This house was built for the Reverend James Dana, the third minister of the Congregational church. It originally had a smokehouse in the attic. George Dickerman, a successful building contractor, renovated the house in the late 1800s. In 1916, the Wallingford Historical Society was founded here; its meetings were held here for a number of years.

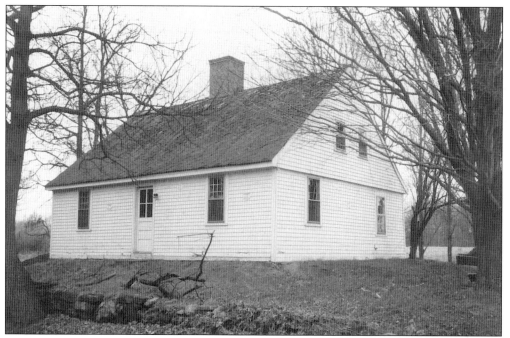

THE BLAKESLEE FARMHOUSE. This house, just off Route 68, was built in the late 1700s, and is considered to be an excellent example of a lower-middle-class farmhouse of that period. The Wallingford Historic Preservation Trust is about to embark on its restoration.

MAMIE PATTEE WITH HER HORSE, C. 1894. This two-door "necessary" provided a degree of privacy for the family members. It was located across the street from the site of Lyman Hall's birthplace on S. Elm Street.

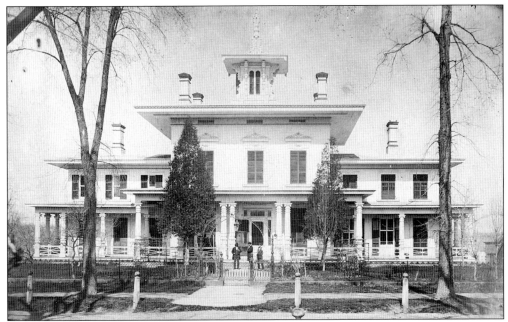

THE MOSES Y. BEACH HOUSE, BUILT IN 1851. After a very successful tenure as owner and publisher of the *New York Sun*, a penny newspaper, Beach returned to Wallingford and built his house in the style of an Italian villa at a cost of $62,000. This mansion on North Main Street stood for 110 years before being replaced by the Union & New Haven Trust Company in 1961.

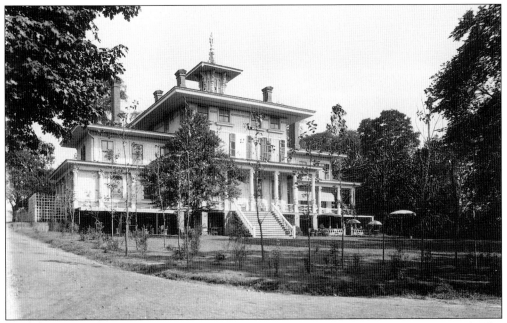

THE BACK OF THE BEACH HOUSE AFTER IT HAD BECOME ST. GEORGE'S INN, C. 1925. The Beach House became the Marlborough House about the turn of the century, and then was St. George's Inn through the mid-1950s. Imagine the elegant garden parties that must have occurred on these grounds.

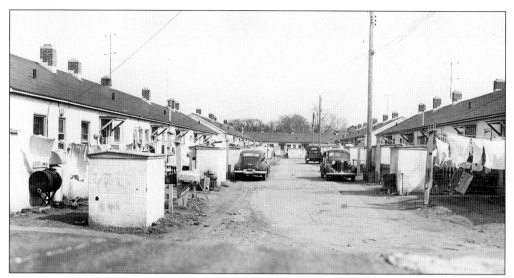

THE HILLCREST HOUSING PROJECT, 1944. During World War II, low-cost barracks-style housing was put in on part of the Williams estate off East Center Street near the current Hillcrest Road. These cinder block buildings helped ease the housing shortage at the time, but were taken down about 1950.

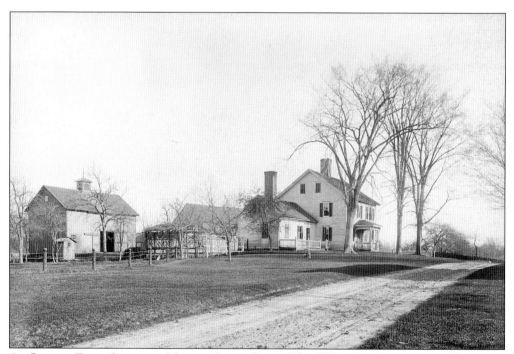

AN IDYLLIC FARM SCENE ON NORTH FARMS ROAD. The Walter Ives farm, pictured here near a narrow dirt road, burned in 1917.

WHAT A WONDERFUL DAY FOR A BIRTHDAY PARTY, 1888. The Frary Hale house, with its pretty Victorian porch, was at 38 South Main Street. In later years, Dr. John Brosnan called it home and had his dental practice here. It was demolished to provide room for the current post office about 1960.

THE CURTIS HOUSE, SOMETIMES KNOWN AS THE "ENVELOPE" HOUSE. When Frederic Curtis, a man of wealth, bought the property, it had a white farmhouse on it. He wanted to build a bigger house on the hill to the west. When his neighbor would not sell the land, he had this replica of Robert Burns's Abbotsford built around the smaller house. There are double walls and ceilings throughout. It served as the headmaster's house at the Choate School for many years.

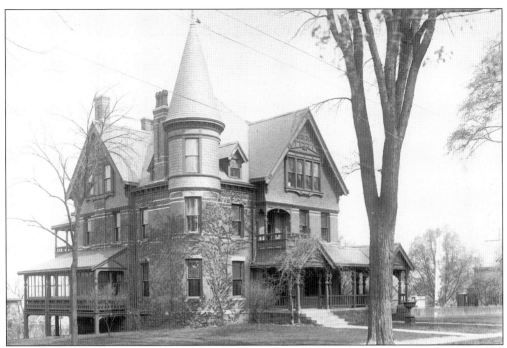

THE HUBERT L. JUDD MANSION, BUILT IN 1887. This house, located on South Main Street where the town hall parking lot is today, was built at a cost of approximately $1 million. It was a residence for less than 30 years. The town bought it about 1916 when the high school was being built. It was home to the Red Cross and later the Wallingford Elks Club. The carriage house is the only reminder of this elegant dwelling.

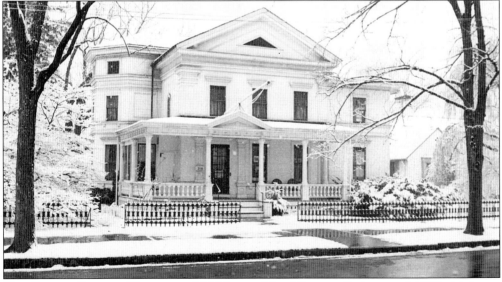

THE SAMUEL SIMPSON HOUSE, AT 216 NORTH MAIN STREET. Built around 1840, this house was home to Samuel Simpson, one of the pioneers in the silver industry and the president of Simpson, Hall & Miller. His great-granddaughter, Mrs. R. Herschel Taber, later ran a bookstore in the house and sold her husband's copper and enamelware. The house has been relocated to 1370 Scard Road.

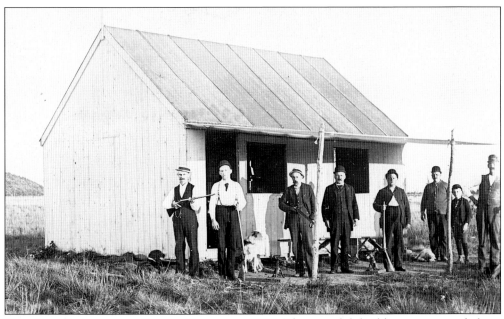

THE GUN CLUB ON THE SOUTH PLAINS, C. 1895. The gun club building was erected about 1889. Pictured here are, from left to right, David Atken, George Gardner, Jack Hinman, ? Wetzel, Bill Gardner, Dan Wetzel, an unknown boy, and George Webb.

The Opening Races

—OF THE—

WALLINGFORD DRIVING

AND CYCLING ASSOCIATION,

... WILL OCCUR ...

May 22, 1897.

PROGRAMME.

2:30 Class, trot and pace................100 Bushels Oats.
2:40 Class, trot and pace.... 100 Bushels Oats.

CONDITIONS.

One-half mile heats, best three in five.
Entrance fee $3.
Purse divided 50, 25, 15 and 10 bushels oats.
National rules to govern.
The right reserved to declare off if classes do not fill satisfactory.

Entries Close May 20th, 11 p. m., with

H. D. PATTEE, SEC'Y,
Wallingford, Conn.

Wallingford, Conn., May 15th.

WALLINGFORD'S OWN RACE TRACK. This program is for the opening day of the 1897 season, sponsored by the Wallingford Driving and Cycling Association. The race track was located on the north side of East Center Street, just east of East Main Street. The WDCA operated the track from 1893 to 1897 on William Williams' property. Please note that the winner would receive 50 bushels of oats.

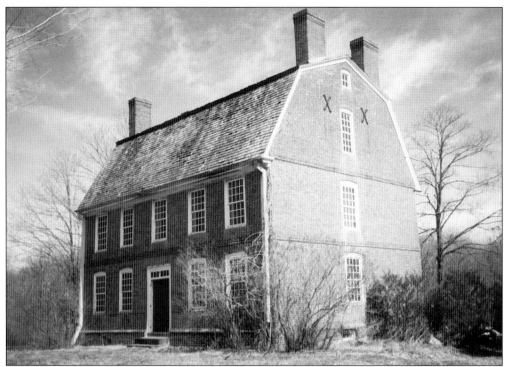

THE JOHN BARKER HOUSE ON CLINTONVILLE ROAD. The main house, built in 1756, is the oldest surviving brick house in Connecticut. The third floor was used as a ballroom and had a "spring" floor for easy dancing.

THE NATHAN HALL HOUSE, BUILT IN 1833. This house, on Williams Road and backing up to the Airline Railroad, was built of native brownstone for Mr. Hall, a pious man. One story has it that the mason put the playing card symbols of a spade, heart, diamond, and club into the wall at the end of the house for spite.

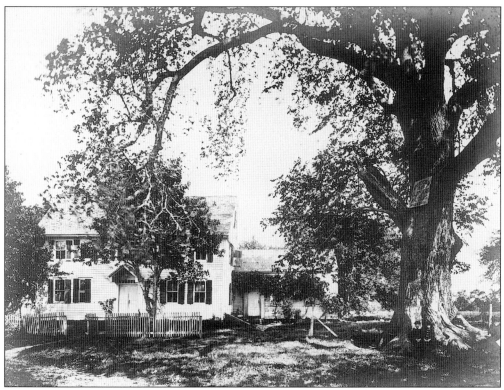

THE NEHEMIAH ROYCE HOUSE, C. 1880. The Royce house was built in 1672. This picture shows the house when it was at the corner of North Street and North Main Street, where it stood until 1924. The large tree is the Washington elm, which was blown down in 1896.

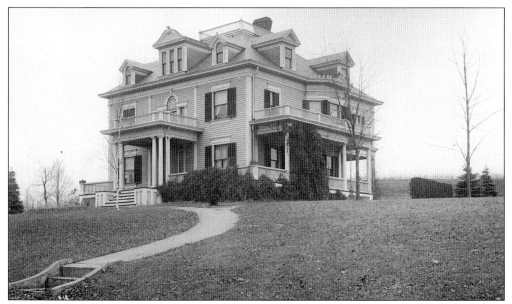

THE J. NORRIS BARNES HOUSE, 924 NORTH MAIN STREET. Once home to the owners of Barnes Bros. Nursery, this house is now occupied by a financial consulting firm.

Ten
PUBLIC SERVICES

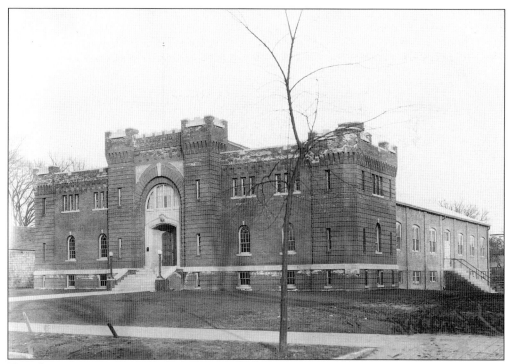

THE CONNECTICUT STATE ARMORY, C. 1921. The armory was built in 1920 as a training facility for Company K. Lyman Hall High School played its basketball games here, and many balls and proms were held here. Today it is home to the Wallingford Police Department.

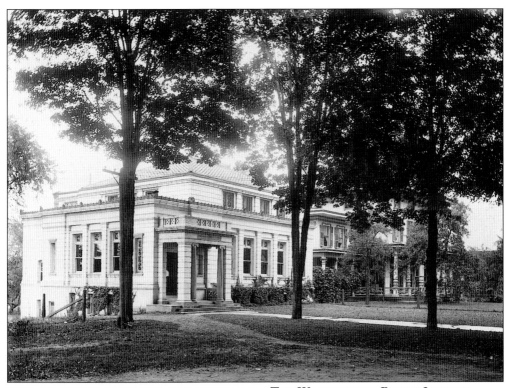

THE WALLINGFORD PUBLIC LIBRARY, 1915. The library was only 16 years old when this photograph was taken, and the addition had not yet been put on for the children's room. St. George's Inn is in the background.

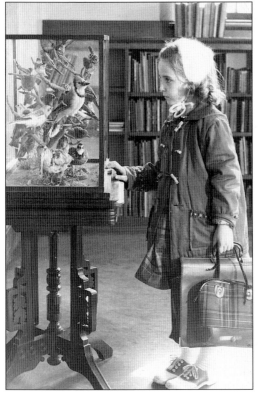

WAITING FOR THE BIRDS TO FLY? In 1959, Marie Gannon pauses to view the once popular bird display in the children's room in the lower level of the Wallingford Public Library.

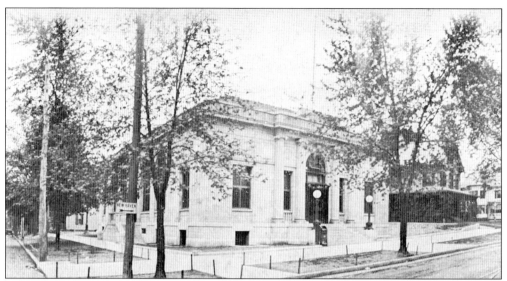

THE U.S. POST OFFICE. This fine granite building opened in 1913, but served the public for less than 50 years before being replaced by the current building.

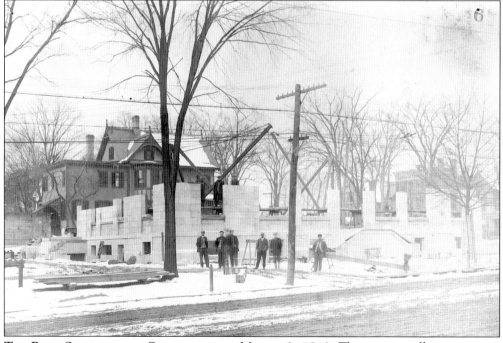

THE POST OFFICE UNDER CONSTRUCTION, MARCH 2, 1912. The granite walls are going up under the watchful eyes of the employees of the Westchester Engineering Co.

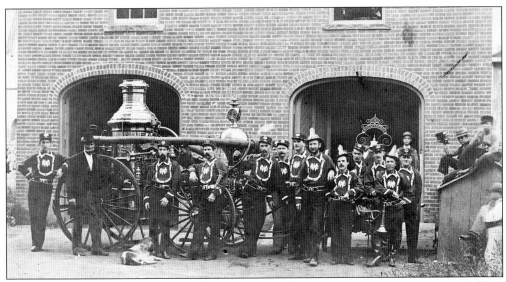

THE SIMPSON HOOK & LADDER COMPANY. The firehouse was behind the old town hall on Center Street.

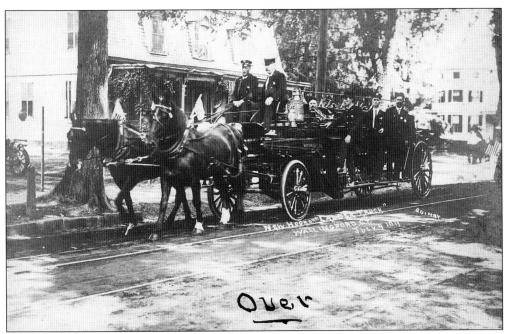

THE NEW HOOK AND LADDER "TRUCK", JULY 4, 1911. The horse-drawn ladder wagon was one of the highlights of the parade. They are passing the Mansfield/Harrison house on North Main Street.

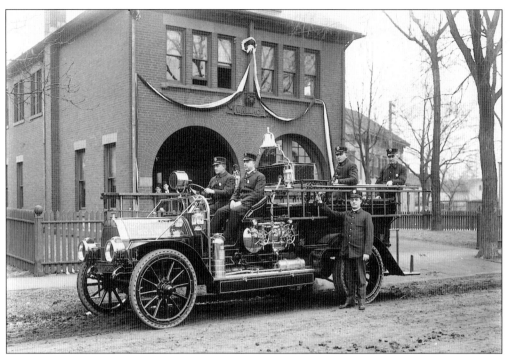

THE FIRST MOTORIZED FIRE ENGINE, 1913. Engine No. 1, with Chief Engineer John Luby as the passenger, is shown here stopped in front of the Wallace Hose Company at the corner of South Cherry and Quinnipiac. John Luby continued as chief for another 23 years.

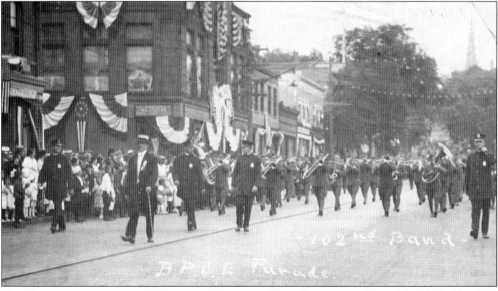

THE BROTHERHOOD OF THE PATERNAL ORDER OF ELKS PARADE OF JUNE 11, 1919. The Elks held a statewide gathering in Wallingford, and many of them participated in the parade. Behind the parade marshal are four of Wallingford's finest, preceding the 102nd Army Band.

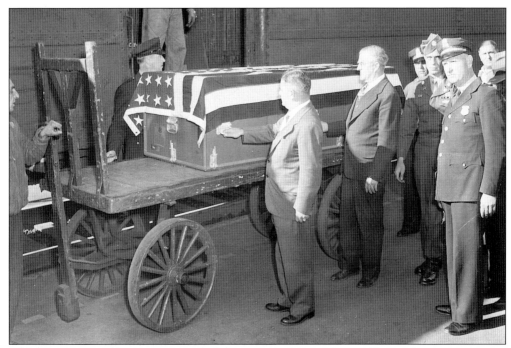

A Flag-draped Casket of an U.S. Serviceman Being Met by Town Officials at the Railroad Siding, 1944.

A Future Mayor and Three of His Army Buddies from World War I. Bill Bertini, at left, became our first mayor four decades after this photograph was taken. He is shown here with an unidentified buddy, Theodore P. Hall, and Stanley Shaw, who was killed in action on September 16, 1917.

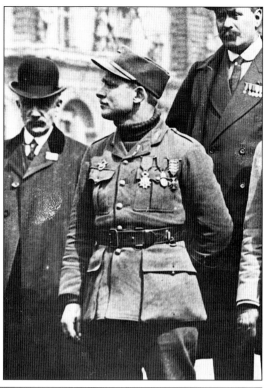

MAJOR GERVAIS RAOUL LUFBERY BEING HONORED FOR HIS 11TH VICTORY. Major Lufbery, a member of the Lafayette Escadrille, is shown here being honored for his 11th victory in single combat. In this case he had downed one of five German planes and escaped to fly another day.

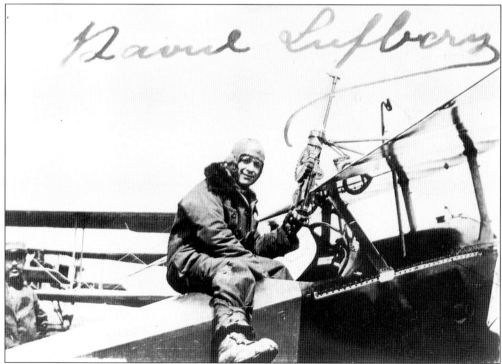

MAJOR LUFBERY IN HIS FLIGHT UNIFORM, ABOUT TO TAKE TO THE AIR. The major sent this photographic postcard to his father on June 6, 1916, well before the Americans entered the war.

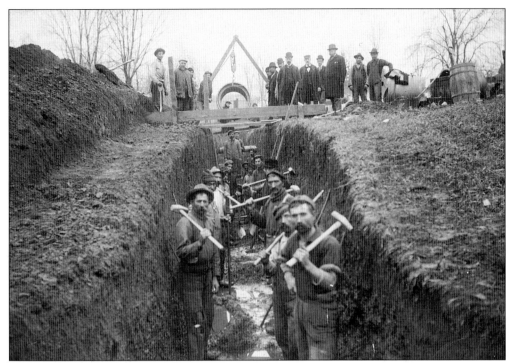

WATER COMPANY EMPLOYEES DIGGING A TRENCH FOR A NEW WATER MAIN, C. 1900. This work was all done by hand.

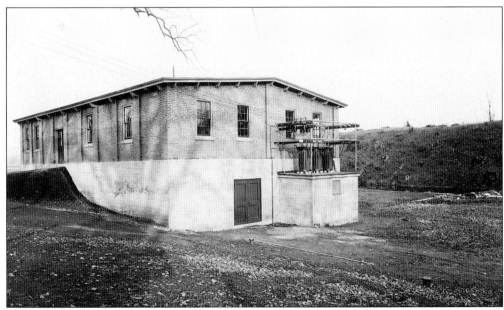

THE MACKENZIE WATER TREATMENT PLANT ON NORTHFORD ROAD, 1926. This was the first "modern" treatment plant that we had for our water supply. It had a capacity of two million gallons

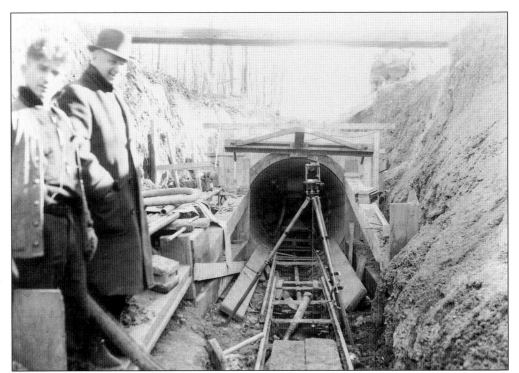

SUPERVISING THE CONSTRUCTION OF THE TUNNEL FOR THE TRUNK WATER MAIN BETWEEN PAUG POND AND THE TREATMENT PLANT, 1937. William MacKenzie, longtime water department superintendent, is inspecting the progress with George Hallenbeck

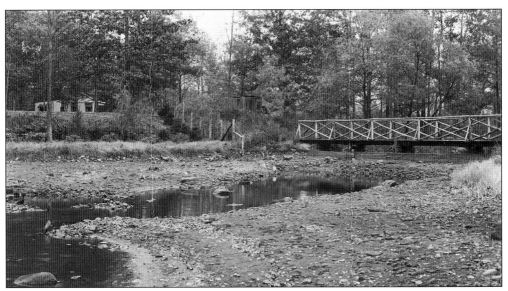

SPRING LAKE DURING THE DROUGHT OF 1941. Although not a deep lake, it has very seldom been this low. The picturesque bridge was close to not being needed that year.

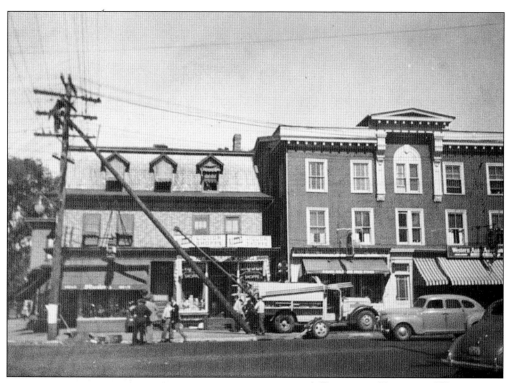

A BOROUGH ELECTRIC WORKS CREW REPLACING A JUNCTION POLE AT CENTER AND COLONY, c. 1946. In the background to the left is Rubin's Mens Store, while Coughlan's Pharmacy is to right.

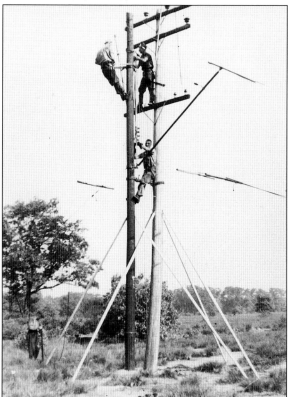

REPLACING THE "HIGH LINE" FROM MERIDEN, 1940. This crew of linemen are transferring the main transmission line from CL&P to a new pole. The working crew from the top is Charlie Buongol, Bob Beaumont, and Clarence Piper (on the pole), while the supervisor on the ground is Charlie Cooper.

ALFRED L. PIERCE, GENERAL MANAGER OF THE BOROUGH ELECTRIC WORKS, 1944. This picture was taken at the summer picnic. Mr. Pierce, for whom the power plant was named in the early 1950s, had been managing the utility for 45 years at this time.

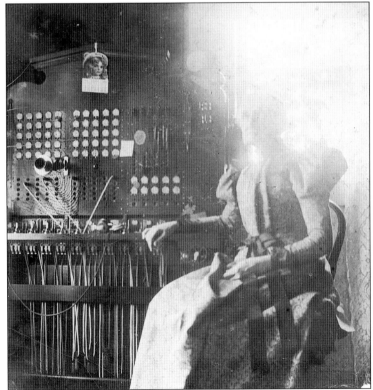

MRS. SYBIL HALL, TELEPHONE OPERATOR. The picture was taken at the first telephone switchboard in Wallingford on Church Street.

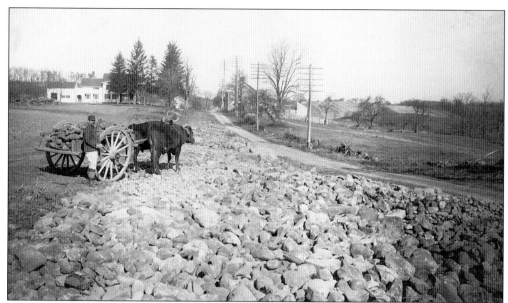

MAKING A NEW ROADBED ON SCHOOLHOUSE ROAD, MID-1920S. The south end of Schoolhouse Road, near Mansion Road, could be very swampy and almost impassable in the winter and spring. As Blue Hills Orchards expanded, the fields were cleared of stones, which were carried by ox carts and horse carts and dumped to form a new roadbed 30 or 40 feet west of the old road. The new roadbed had several feet of stone for a base before being covered with a thick layer of soil. Paving was still a number of years away. The utility poles still run alongside the old roadway, now part of the field.

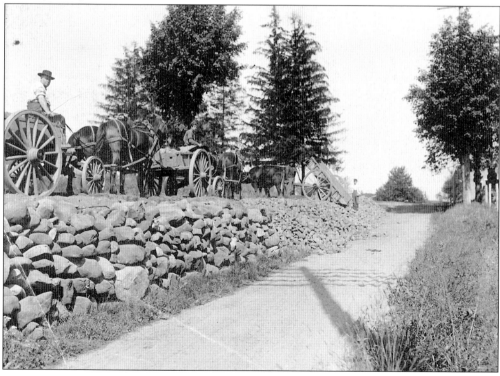

Eleven
FARMS AND ORCHARDS

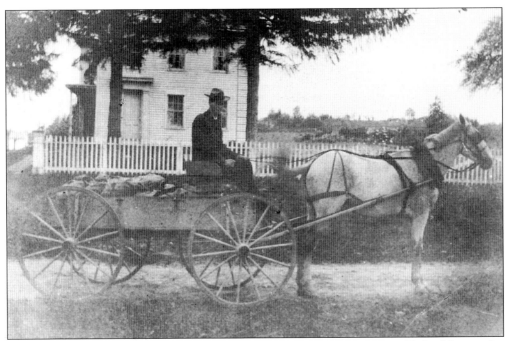

A.T. HENRY'S FIRST CROP GOING TO MARKET, AUGUST 1905. Arnon Taylor Henry, who founded Blue Hills Orchard in 1904, is shown here in front of his house on School House Road with a wagon full of cabbages, about to take his first cash crop to market. In time Blue Hills would become known for its peaches and cherries, as well as its apples and pears. This area of town was known as "Blue Hills" as early as the 1670s.

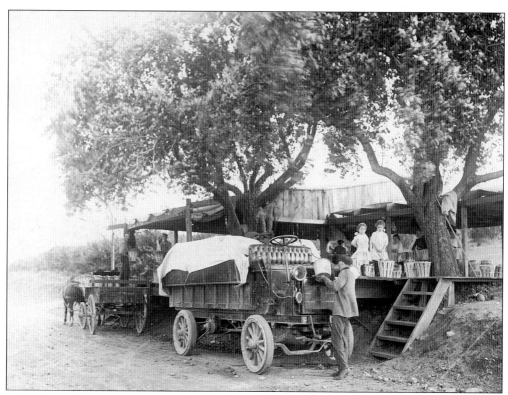

A.T. Henry's Peach-Packing Plant, c. 1916. Located on the south side of Mansion Road, to the east of School House Road, it was one the first plants of its type in this area. Isabel and Clara Henry, on the platform, are watching water being added to the chain-drive truck full of peaches.

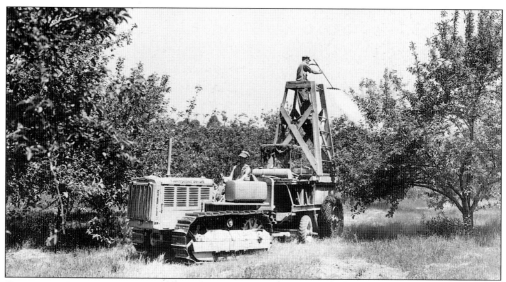

Spraying Apples at Blue Hills in 1939. How times change—a Caterpillar Diesel D-4 tractor is now used to pull the spray rig through the orchard. Oliver Burghardt, later grand master of the Grange, is the driver.

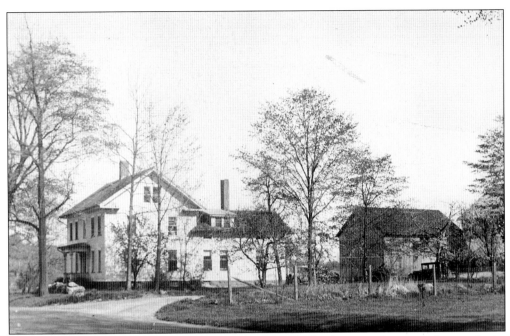

BEAUMONT FARM ON MAPLEWOOD AVENUE, C. 1925. The farm, just becoming known for its dairy products at this time, had been in the family for 120 years. Electricity, which would ease the workload, was still a year or two away.

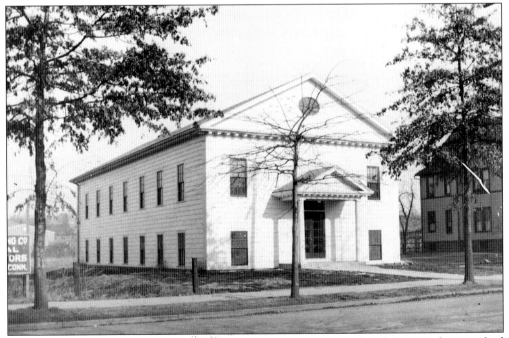

THE GRANGE HALL IN 1933. The Patrons of Husbandry, as the Grange is known, had been an integral part of the community for over 40 years before the hall was dedicated on February 9, 1933.

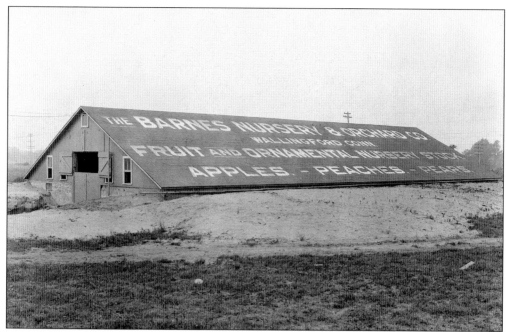

THE BARNES NURSERY AND ORCHARD COLD STORAGE FACILITY. This facility was located on North Colony Road, opposite Ives Road, with the railroad directly behind it. The location made it easy to load the fruit into the boxcars for shipment to one of Gerber's food plants.

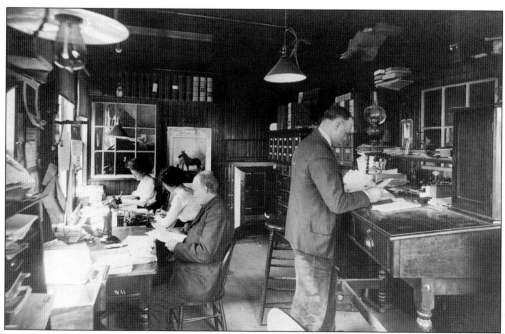

THE INTERIOR OF THE BARNES BROS. NURSERY CO. OFFICE. Until the 1950s, the Barnes family ran a very successful nursery business off North Colony Road on both sides of the current Route 68.

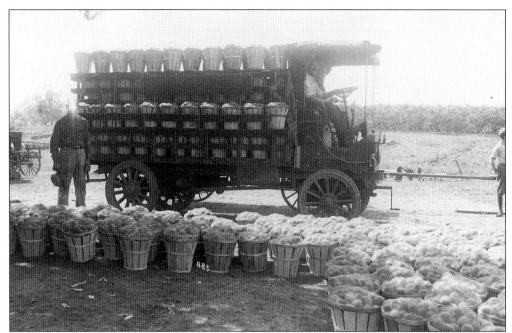

PEACHES READY FOR MARKET AT BARNES BROS. ORCHARDS, C. 1918. It looks like the truck has a full load. The top row of baskets seem to be perched rather precariously for the none-too-smooth roads of that day. All of the baskets are covered in netting to keep insects away.

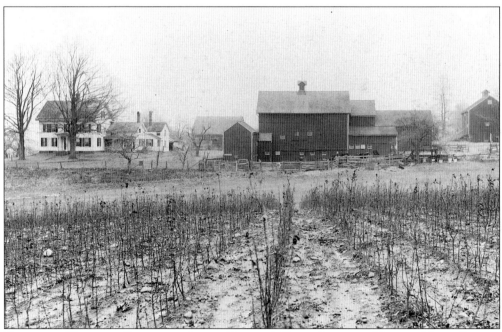

ORCHARD NURSERY STOCK AT JAMES BARNES' FARM EAST OF NORTH MAIN STREET EXTENSION. Row after row of bushes and trees could be seen for years on North Main. In the early 1920s, most of the barns burned. The house was saved, but the fire was so hot that the paint on the east side blistered and almost ignited.

HELEN AND DELAPHINE BARNES AT GRAMPA PADDOCK'S FARM ON EAST MAIN STREET.

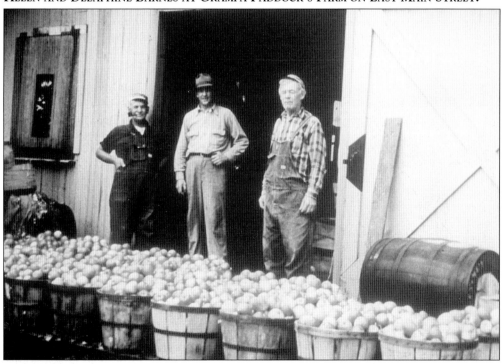

PERKINS BROS. ORCHARDS ON OLD DURHAM ROAD. The Perkins brothers, Arthur and Burton, came to town in 1928 and started an orchard business, growing apples and peaches and making cider. The Choate students came to buy cider. Some of the boys would add raisins and store it in their closets only to have the concoction explode.

Twelve
YALESVILLE

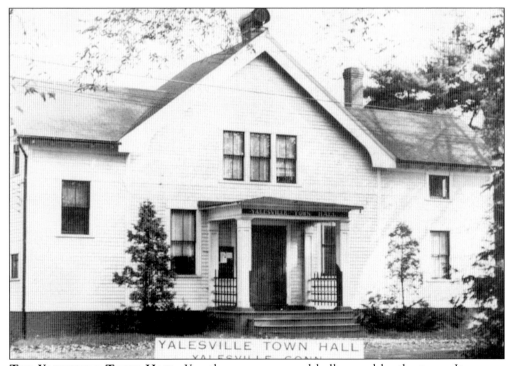

THE YALESVILLE TOWN HALL. Yes, there was a second hall owned by the town. It was on Chapel Street and served as a community center, rather than as a hall of records. It was a fine place for get-togethers and dances.

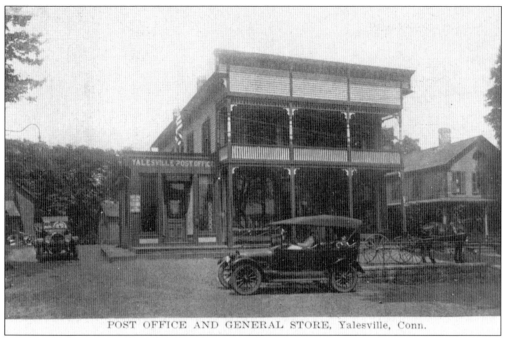

THE YALESVILLE POST OFFICE AND MCKENZIE'S STORE ON MAIN STREET. This was one of several locations for the post office. McKenzie's, with groceries and more, was a fixture in Yalesville for many years.

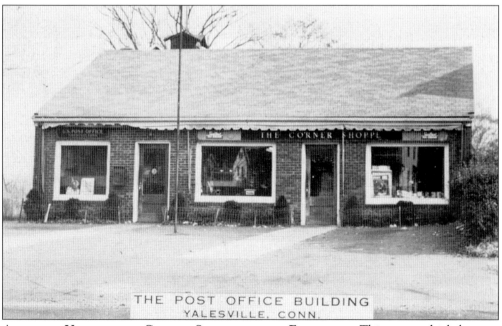

AN EARLY VIEW OF THE CORNER SHOPPE, BEFORE EXPANSION. This store, which became synonymous with Yalesville, had the post office for an early neighbor on Church Street.

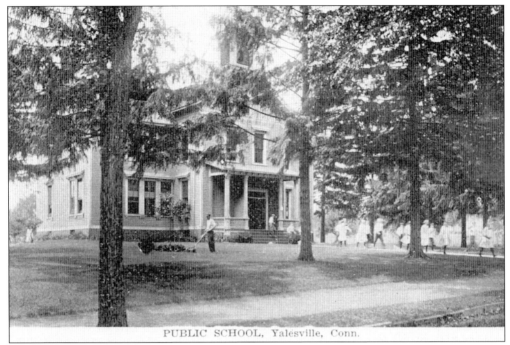

THE YALESVILLE PUBLIC SCHOOL. This handsome school, visible through the trees, was built before the turn of the century with a bell tower. Some of the students referred to it as the "old green jail."

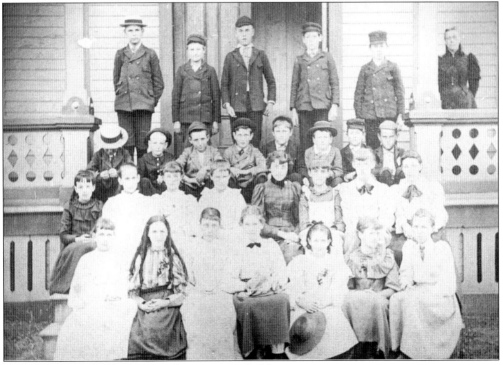

STUDENTS AT THE YALESVILLE SCHOOL, 1889–90.

LOOKING UP HANOVER STREET. In the days of yore, when there were few houses on the street, the Meriden trolley used to run between South Meriden and the Wallingford railroad station.

COOK'S GAS STATION ON CHAPEL STREET. The single gas pump was on the side of the station. On a summer's day you could cool off with some ice cream while your gas was being pumped.

THE INTERIOR OF THE ORIGINAL
ST. JOHN THE EVANGELIST EPISCOPAL
CHURCH AT 360 CHURCH STREET.

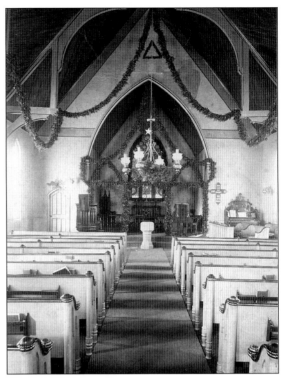

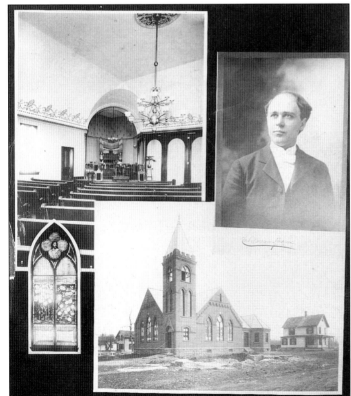

THE YALESVILLE UNITED
METHODIST CHURCH AT
8 NEW PLACE STREET,
c. 1902. This church,
now approaching its
centennial, originally had
a taller steeple than it
does today.

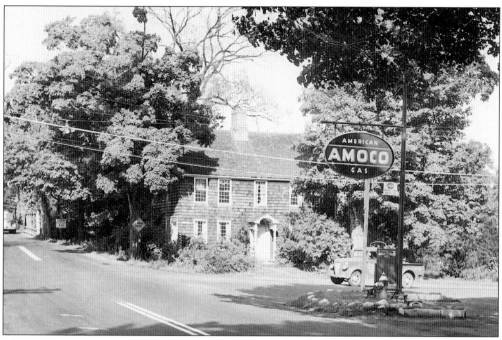

MAIN AND CHURCH, C. 1935. The old Tracy, or McKenzie, house graced this corner for many years. Please note the Dickerman's Hardware Store pickup approaching the intersection with just a caution light.

SAMUEL TYLER, THE LAST TYLER TO RUN TYLER'S MILLS. For over 100 years the Tylers ran the mills located where the Troutbrook Brewery is today. The first of the line ran what was originally the town's gristmill, taking ownership of it in 1704. Over the years other mills were added. Charles Yale purchased the mills prior to 1820, and after that the area became known as Yalesville.